IMAGES
of America

EDGAR ALLAN POE'S
BALTIMORE

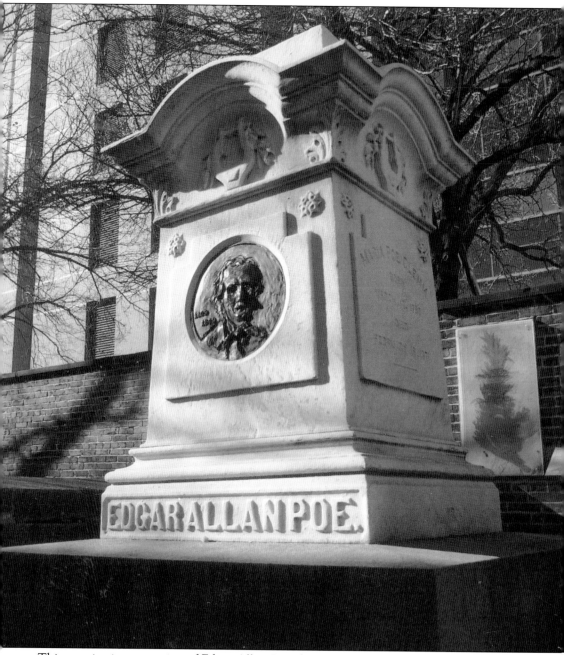

This emotive interpretation of Edgar Allan Poe's burial monument by Anthony Washington confers a degree of silence and seclusion not possible in a daytime photograph. Here, the marble marker is marooned from the daily surge of animation. (Anthony Washington.)

ON THE COVER: From 1833 to 1835, this house at 203 North Amity Street in Baltimore was the residence of one of America's greatest writers, Edgar Allan Poe. It was while living here that Poe was first paid for one of his compositions, marking the start of his professional literary career. The house has been designated a National Historic Landmark and today is visited annually by thousands from around the world. (Author.)

IMAGES
of America

EDGAR ALLAN POE'S
BALTIMORE

David F. Gaylin

ARCADIA
PUBLISHING

Copyright © 2015 by David F. Gaylin
ISBN 978-1-4671-2316-7

Published by Arcadia Publishing
Charleston, South Carolina

Printed in the United States of America

Library of Congress Control Number: 2014950324

For all general information, please contact Arcadia Publishing:
Telephone 843-853-2070
Fax 843-853-0044
E-mail sales@arcadiapublishing.com
For customer service and orders:
Toll-Free 1-888-313-2665

Visit us on the Internet at www.arcadiapublishing.com

To Anna Gaylin
"Thine absence is the night."

CONTENTS

ACKNOWLEDGMENTS

Producing a book of images on a story that takes place largely before the invention of the photographic process presented a few challenges. Fortunately, many of the sites and structures associated with Poe's Baltimore story survived into the photographic era and were duly captured for posterity; regrettably, many were not. For the latter, it became necessary to rely on drawings and engravings, particularly with personal portraits of those individuals who were integral to the narrative. This was only possible through access to immense archival resources, including the Enoch Pratt Free Library, Sheridan Libraries at Johns Hopkins University, Baltimore Sun Archives, and Maryland Historical Society, among others. With these assets, I enjoyed the assistance of many individuals, without whose guidance and knowledge I would have been lost.

I would like to thank the following people, to whom I am greatly indebted: Dr. Carla Hayden, Wesley Wilson, and Michael Johnson at the Enoch Pratt Free Library; Eben Dennis at the Maryland Historical Society; Zach Dixon at the Baltimore Sun Archives; Kate Wodehouse at the Providence Athenaeum; Jullianne Ballou at the University of Texas at Austin; Jim Stimpert at the Eisenhower Library at Johns Hopkins University; Chris Semtner, author and curator of the Museum of Edgar Allan Poe, who unselfishly gave his time, information, and images; Courtney Wilson and Jane Harper at the B&O Railroad Museum, for allowing access to the Poe Collection; Maureen Ottinger and Ritz Camera, for going above and beyond; Lisa Lewenz at the Edgar Allan Poe House, who forgave my many absences; and Gillian Nicol at Arcadia Publishing, for her expertise and patience. To Kristen Harbeson, who believed in the project from the very start and removed barriers along the way, go my deepest thanks—without her, this book simply could not have happened. Finally, I would like to express a special appreciation to eminent Poe scholar Jeffrey Savoye, who provided guidance, found critical photographs, and painstakingly reviewed the text to save me from many embarrassments.

Every effort was made by the author to ascertain the sources of the images shown and assign the correct attributions. For uniformity, photographs taken by the author and those in the author's collection as well as images in the public domain are simply credited "Author."

INTRODUCTION

Whether or not one is an admirer of Edgar Allan Poe, most of us almost certainly have heard of him. What student has not read "The Tell-Tale Heart"? Here in Baltimore, there is no escape from the man. The city is dotted with sites associated with the great American poet and story writer: the food markets that nourished him and the brick towers that nourished his imagination; the train depots he used when he had money, and the streets he walked when he did not; the fine townhouses of his patrons and the spartan house where he not so much lived, but survived; the hospital building where he spent his last moments and his churchyard gravesite where many come to spend moments in reflection. And for those not given to visit the city's historical sites, the professional football team in Baltimore has been named after one of his poems.

Although Poe is inextricably linked to Baltimore, it should be said that this is just one of several US cities that are identified with him. He was born in Boston, Massachusetts, and his first book of poems, *Tamerlane and Other Poems*, was published there. During his literary career, he lived in Philadelphia longer than in any other city, from 1838 to 1844. While there, he wrote many of his more well-known works, including "Murders in the Rue Morgue," "The Pit and the Pendulum," and "The Fall of the House of Usher." His most celebrated poems—"The Raven," "Annabel Lee," and "The Bells"—were produced while he resided in New York City from 1844 to 1849. For a short period there, he realized his dream of becoming a magazine publisher. Richmond, Virginia, was the place of his youth. When Poe was only two, his mother died while working in that great city, leaving him and his siblings orphaned. Edgar was fostered by the family of a prosperous merchant there, John Allan, and received an exceptional education that included schooling in England and attendance at the newly created University of Virginia. Some who knew Poe said he had the accent and comportment of a Virginia gentleman.

Yet Baltimore's affiliation with Edgar Allan Poe is arguably the strongest. His Irish ancestors settled in the port city during the 18th century and became prominent citizens. His grandfather was a hero of the American Revolution, and Poe's father lived in the city for most of his life. When Poe fell out with his foster father, it was with his birth father's family in Baltimore that he found a safe port in his stormy life. While living here from 1831 to 1835, he began writing short stories that were more marketable than his poetry. In 1833, he won recognition and a cash prize from the *Baltimore Saturday Visiter* for his tale "MS. (Manuscript) Found in a Bottle." Poe had managed to get published before this time, mostly through his own devices, but it was while living in this city that he was first paid for one of his productions, marking the beginning of his professional literary career and Baltimore as the place of his discovery. After moving away from the city in 1835, he returned to visit many times and sustained relationships with the acquaintances he made here. Then, while passing through Baltimore in October 1849, he was stricken and died mysteriously, becoming a permanent resident. Each year, his Fayette Street burial site attracts thousands from around the world.

The Baltimore that Poe knew in the early part of the 19th century was the quintessential "boomtown." The region north of the Patapsco River had been established in 1659 as Baltimore County, and, in 1729, a smaller area above the river's north branch was designated by the state legislature for "erecting" a town. As recorded in an early directory, "By this act Baltimore was to be a privileged place of landing, loading and selling, and exchanging goods." The following year, a surveyed plan was made, and the town began to grow at such a rate that, in a span of just 33 years, the nearby settlements of Jones Town and Fells Point had been absorbed.

In 1732, the city's exports of tobacco, lumber, and skins were estimated at 24,000 tons. With the town's dependence on trade with England, Baltimore had no shortage of loyalists during the American Revolution, but the majority of its citizens were devoted to the cause. In 1777, during one of the first recorded riots in the city, Edgar's grandfather David Poe Sr. was listed among those accosting a Tory newspaper editor, and when Lafayette was passing through the town on his way to reinforce Gen. Nathanael Greene's army in Virginia, David's wife, Elizabeth, organized the effort to supply his troops with needed clothing.

By 1790, seven years before the city's incorporation, the population was 13,500; within a decade, this number doubled to 26,500. The commercial advantages of navigable waters and ready access to the bay attracted many who wanted to establish a trade or set up shop. Baltimore's export-driven economy, recovered from the Revolution, was ruined once more after the War of 1812, a conflict that spawned the privateers' "nest" in Fell's Point. Again, the city was divided, as demonstrated when rioters attacked an antiwar, federalist newspaper office, with deadly results. It was during this time that Baltimore earned the moniker "Mob Town" for its inhabitants' proclivity to riot. Political gangs, fire companies, and, later, railroad workers seemed to be especially eager participants. One of the worst events occurred over a four-day period in August 1835 as a reaction to the failure of the Bank of Maryland. Some of the city's finest mansions were destroyed, and as many as 22 people were killed.

With Baltimore's growing wealth, mansions were being added faster than the people were burning them down. Much of what is seen today as the "old" Baltimore was created during the early part of the 19th century, including the following: the Mount Vernon district and Washington Monument, the Basilica, the 1814 Battle Monument, the Pantheon-like Davidge Hall of the University of Maryland, the Shot Tower, and the Peale Museum (today, the Peale Center). In 1822, the city's street plan employed today was created and adopted.

This was the "Dodge City on the Chesapeake" in which Edgar Allan Poe found himself trying to start a career with his pen, a boisterous town bursting at the seams and an unlikely environment for contemplative undertakings. There can be little question that the sights and sounds of this throbbing city had an influence upon the tenor, if not the topics, of his works. *Edgar Allan Poe's Baltimore* is an attempt to depict the city and the citizens that he knew. It was a place for Poe of many beginnings and, ultimately, one ending. It is hoped that those reading this small volume may find in it stimulation to visit these sites in the city of Baltimore and learn more about one of America's greatest writers.

One

GROWING PAINS
1797–1828

Edgar Allan Poe, the great champion of Southern literature, was born a Yankee. His parents, David Poe Jr. and Elizabeth Arnold, both working in show business, were performing in Boston, Massachusetts, when Edgar was born on January 19, 1809. Stage actors, they traveled the Eastern Seaboard with several theater companies. While in Richmond, Elizabeth lost her long battle with tuberculosis and died on December 8, 1811; David Poe was no longer with his wife. This made orphans out of little Edgar and his newborn sister, Rosalie, who were taken in by two separate families of that city. Edgar was fostered (never adopted) by John and Frances Allan. He was given a privileged upbringing and an education to which very few at that time could aspire. Although his relationship with Frances was one of affection, his adolescent years with John Allan were marked by conflict. When the two became completely disaffected, Edgar Poe would seek and find shelter with his ancestral family in Baltimore.

Poe's birth followed Baltimore's incorporation in 1797 by only 12 years. Of course, by this time, the city had long been the largest in the state (the population was 10 times that of Annapolis), but this charter allowed distinct representation from Baltimore County at the capitol. Boundary lines and political wards were established, but city offices and commissions remained mostly unchanged; James Calhoun would continue as mayor until 1804. By 1810, the city's population had swollen to 46,500, making it the third-largest in the young nation. After the economically devastating War of 1812, Baltimore, like the nation, turned much of its commercial attention inward, toward the building of infrastructure and trade with the emerging states as well as the existing confederation. The city's answer to the growing canal network in the north was an overland railroad system. The Baltimore & Ohio Railroad was established in 1827; its ultimate impact on the city's economy would be far-reaching.

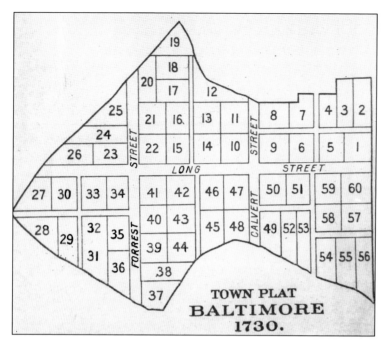

The town of Baltimore was created by an act of the Maryland Legislature in 1729. In January of the following year, the original survey was made at the northern branch of the Patapsco River, creating 60 one-acre lots and three streets—Calvert, Forest (later named Charles), and Long (later named Baltimore). The first docks built over the harbor were in the area that is now Redwood and Water Streets. (Author.)

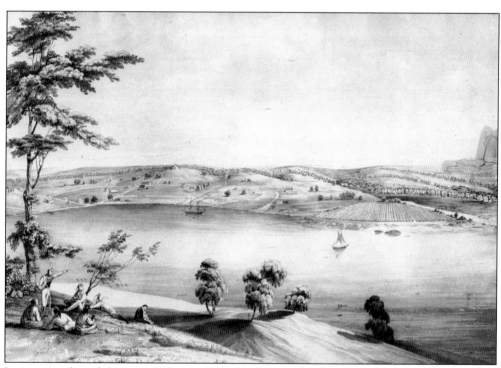

In a marine list of the port, Baltimore Town is described as "200 inhabitants; 25 houses, four of them brick; one church, two taverns." This 1752 rendition of Baltimore is less picturesque, but more realistic, than the widely circulated drawing by John Moale Jr. The marshland being cultivated on the right, at the mouth of the Jones Falls, is where Port Discovery and Power Plant Live are today. (Author.)

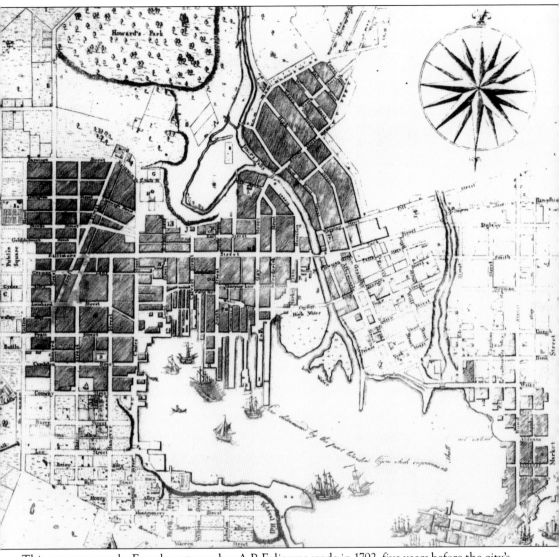

This accurate map by French cartographer A.P. Folie was made in 1792, five years before the city's incorporation. By this time, the settlements of Jones Town (northeast of the Jones Falls) and Fell's Point (east of Harford Run) were already jigging to Baltimore's tune. The lower area of the Jones Falls was still a marsh, a barrier that forced all to go north to what is now Lombard Street to cross. Close examination of the map shows remnants of the harbor's original northern shoreline at Water Street and the earlier docks north of Pratt Street still in place—the larger wharfs below could reach deeper water, rendering obsolete those above. Charles Street, still the harbor's western boundary, had not advanced farther north than Saratoga Street. Above it, where the Washington Monument is today, was John Eager Howard's estate, Howard's Park. (Author.)

This early view of Baltimore city appears to show the intersection of Baltimore and Charles Streets, as suggested by the Catholic cathedral on the hill above. During rainy periods, the harbor would often disrespect the man-made confines and reclaim its territory, flooding areas up to Baltimore Street. The spaces between the stepping-stones that permitted the passage of horse-drawn wagons required some diligence by pedestrians to negotiate. (Author.)

According to Col. J. Thomas Scharf, by 1764, Fell's Point "contained all the artisans and articles requisite for building and fitting vessels, and was already a rival of the town." The point, fronted on deeper water, became a shipbuilding center, but commerce-driven Baltimore quickly outgrew it. This view of Broadway includes the market buildings and St. Patrick's Church, all familiar sites to Edgar Poe, the Baltimorean. (Author.)

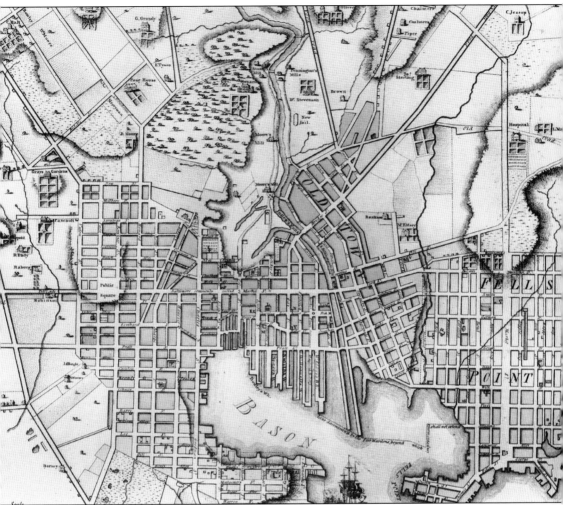

This close-up of Warner and Hanna's 1801 map of Baltimore identifies all three settlements, including Jones Town (now called Old Town) and Fell's Point. Baltimore Street was still called Market, and the earlier piers north of Pratt were still in place, as their owners fought the street's completion. The Jones Fall's meandering course to Calvert Street had been redirected to the east, and the forested estate of John Eager Howard still loomed large to the north. (Author.)

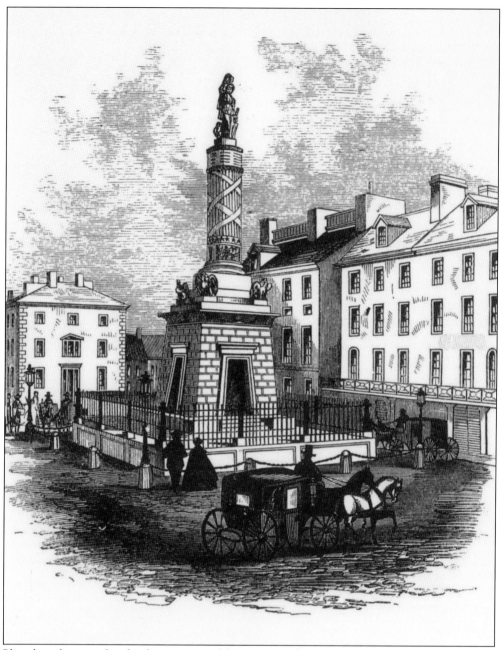

Placed in what was already a historic part of the city, on Calvert Street, the white marble cenotaph was erected in honor of those who fell at the Battle of North Point, which successfully repelled the 1814 British ground attack on Baltimore town. Designed by J. Maximilian Godefroy, the 52-foot-high *Lady Baltimore* was completed in 1825 and became the official symbol of the city two years later. (Author.)

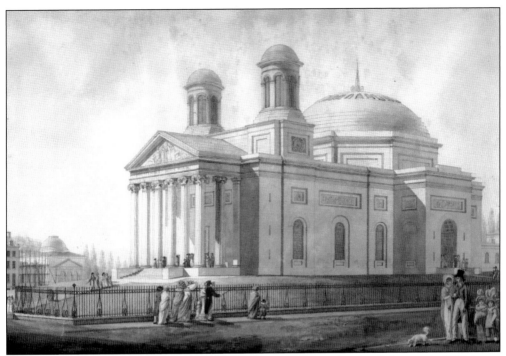

When the first Catholic cathedral in the United States was completed in Baltimore in 1821, it was the highest structure in the city until the erection of the Phoenix Shot Tower seven years later. It was designed by Benjamin Henry Latrobe. During construction, two lotteries were needed to secure funding to complete it. Later modifications included an iron fence around the grounds to protect against stray pigs and cows. (Enoch Pratt Free Library.)

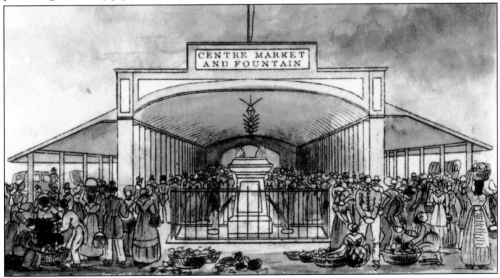

In 1784, the city's center market was relocated to the drained marshland near the Jones Falls, where it would better serve citizens and suppliers. Eventually, two market buildings would be constructed; one was surmounted by the Maryland Institute. A third structure, the well-known Fish Market (now Port Discovery), was also built. In 1817, a fountain of running water for the public was added by the city. (Maryland Historical Society.)

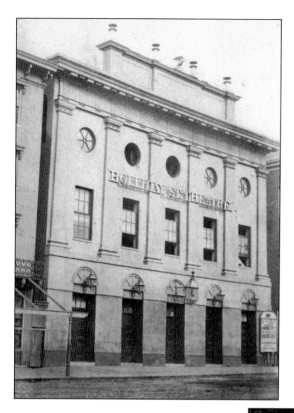

During the spring and summer of 1799, Edgar's future mother, at the age of 12, was among those performing at the New Theater on Holliday Street in Baltimore. By 1813, the small wooden building had been replaced by this more impressive structure, designed by Robert Carey Long. Later, Poe lived nearby on Wilks Street. He would have passed the theater many times, perhaps thinking of his mother. (Maryland Historical Society.)

Poe's parents were stage actors who toured the East Coast. His father, David Poe Jr., had once studied law with William Gwynn in Baltimore, but decided instead to become an actor, against the wishes of his parents. Edgar's mother, Elizabeth "Bettie" Arnold (pictured), was still an attractive widow at 19 when David married her in 1806. (University of Texas at Austin.)

Poe's parents were working in Boston when he was born on January 19, 1809. Although no known images of Edgar's father exist, this miniature of his mother was said to have always been carried on Poe's person. Family tradition holds that, when little Edgar was only five weeks old, he was left with grandparents (not clear which) in Baltimore, while Elizabeth and David continued on tour. (Enoch Pratt Free Library.)

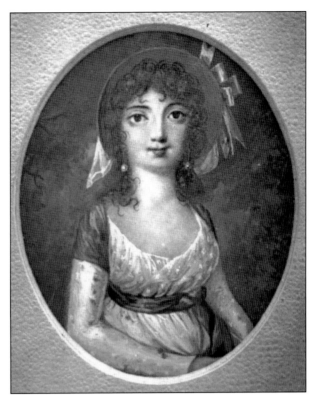

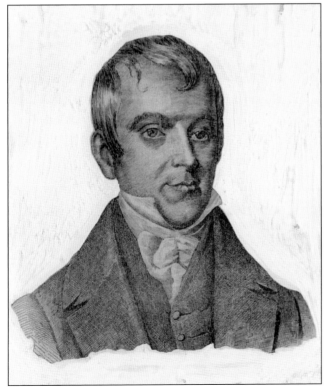

Hezekiah Niles, a Philadelphia-area journalist, moved to Baltimore in 1805. In 1811, he founded *Niles' Weekly Register*, a newsmagazine with political emphasis. It became one of the most influential publications in the United States, with Niles doing much of the writing and editorials. His anti-banker comments would fuel the Baltimore bank riots of 1835. (Author.)

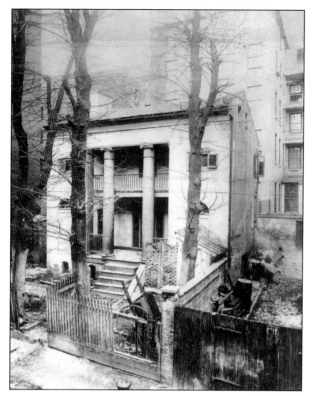

The Tusculum was the Bank Lane home of William Gwynn and, later, a meeting place of the Delphian Club, a coterie formed in 1816 to foster literary and scientific pursuits. Poe may have been parodying this group with his "Folio Club," an imaginary society used as a device to launch his early tales, including the first for which he was paid, "MS. Found in a Bottle." (Johns Hopkins University.)

Although the publishing center of the country in the early 19th century was New England, Baltimore was far from a literary backwater. The city had its own newspaper by 1773 (*Maryland Journal & Baltimore Advertiser*), and, from 1815 to 1833, no fewer than 72 separate periodicals were announced for publication. *The Portico*, the unofficial organ of the Delphian Club, bowed in January 1816. (Author.)

Jehu O'Cataract was the whimsical pseudonym employed by Delphian Club founder John Neal, shown here later in life. Poe said he gave "the very first words of encouragement I ever remember to have heard" when critically recognizing his poem "Heaven" in the pages of the *Yankee and Boston Literary Gazette* in 1829. Neal left Baltimore and eventually returned to Portland, Maine, the place of his birth. (Library of Congress.)

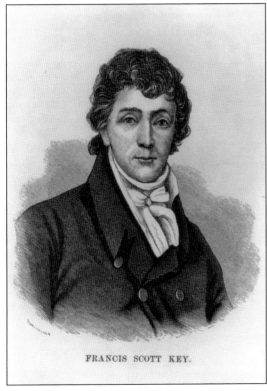

FRANCIS SCOTT KEY.

Francis Scott Key's song "The Star-Spangled Banner" made him an instant celebrity. He was associated with the Delphian Club, but the depth of his activity is not known; some believe his membership was only an honorary one. Like Edgar Allan Poe, he died in Baltimore during the 1840s while only visiting. (Library of Congress.)

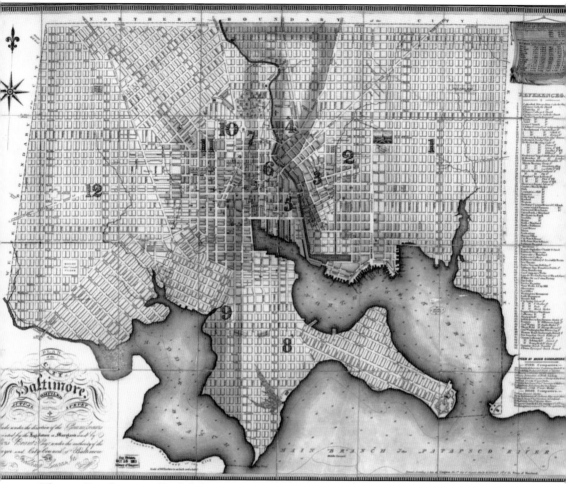

Thomas Poppleton, an English-born surveyor, immigrated to the United States two years before the War of 1812. During the war, he won a contract to create a survey of the city of Baltimore. The plan, finally approved in 1822, did a brilliant job of knitting together the mismatched streets of the three settlements, but it was indifferent to the topography, creating drainage problems that exist to this day. Some have said jokingly that this was Poppleton's war effort for Mother England! (Author.)

Poe was only two years old and traveling with his mother when she died in Richmond, Virginia, leaving him and his siblings orphaned. Largely through the wishes of Frances Allan, she and her husband, John, took Edgar in, although he would never be officially adopted. Poe's relationship with Frances was marked by affection. When she died in February 1829, Poe was, in effect, orphaned a second time. (Johns Hopkins University.)

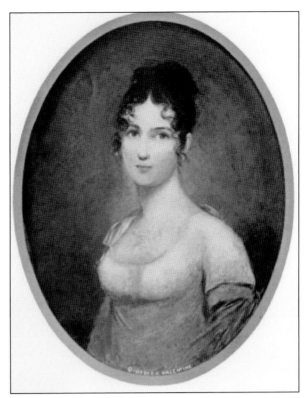

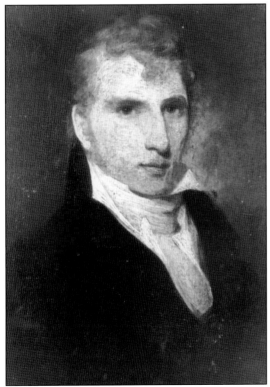

The much-maligned John Allan, Poe's foster father, is shown here as a young man. A well-off Richmond merchant, he afforded Edgar a primary education that few at that time received. Allan even stood him for a term at the newly created University of Virginia. But, without supervision and, perhaps, an inadequate allowance, Poe got into serious pecuniary trouble. When Allan withdrew his financial support, Poe could not return. (Edgar Allan Poe Museum.)

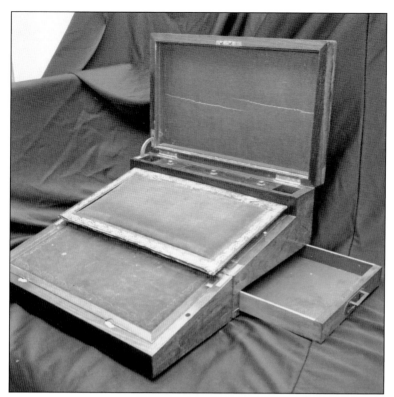

This folding travel desk once belonged to John Allan and is believed to have been loaned to Edgar Poe while he attended the University of Virginia. It was passed down to John Allan's granddaughter and then acquired by Poeana collectors Mr. and Mrs. Sumner Parker, who bequeathed it to the City of Baltimore in 1972. It is on display at the Edgar Allan Poe House. (Poe Baltimore.)

This telescope is believed to have belonged to John Allan when Poe was a family member. It was donated to the City of Baltimore and is on display at the Edgar Allan Poe House. Poe biographer Hervey Allen would say of it, "Through its lenses the eyes of young Israfel first became familiar with those stars and constellations, the lovely names of which are strewn through his poetry." (Poe Baltimore.)

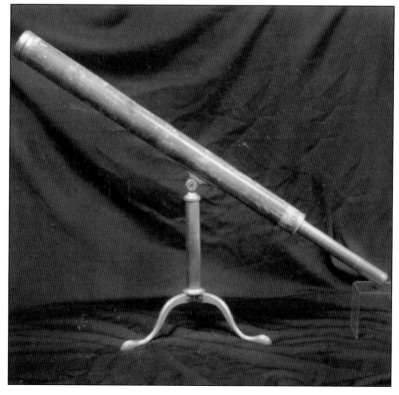

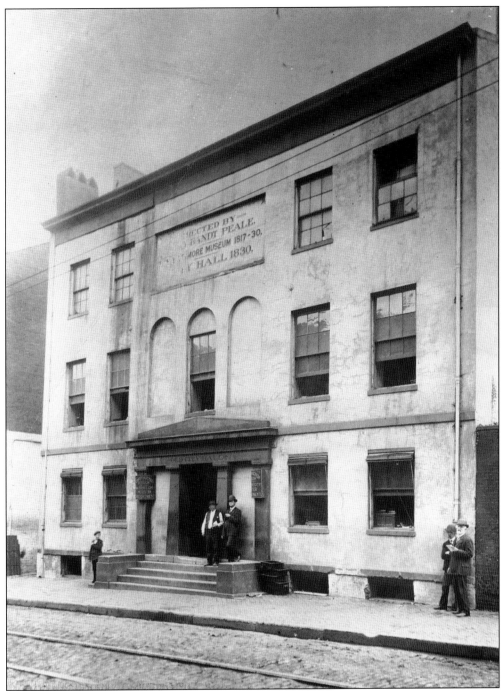

Built specifically as a museum in 1814 by Rembrandt Peale, this was one of the first buildings in the country to be illuminated by gas lighting. It would also serve as Baltimore's city hall building from 1830 to 1875, when Edgar Allan Poe was a resident. The building, at 225 North Holliday Street, is home to the Peale Center for Baltimore History and Architecture. (Library of Congress.)

When visiting Baltimore on his tour of the United States in 1824, the Marquis de Lafayette stayed at the Fountain Inn. After visiting the grave of Edgar Allan Poe's grandfather David Poe, his quartermaster during the American Revolution, Lafayette met with his widow (Poe's grandmother) at the hotel. The meeting called attention to her desperate financial circumstances, for which the state legislature bestowed a small pension. (Enoch Pratt Free Library.)

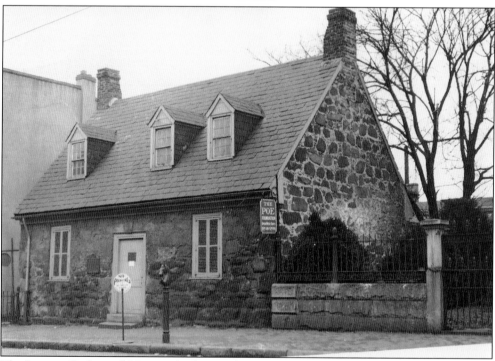

This house in Richmond, Virginia, built around 1740, is believed to be the oldest original structure in the city. When Lafayette toured Richmond in 1824, he reportedly stopped at this house to visit its residents, the Ege family. As a member of the honor guard escorting Lafayette, Edgar Allan Poe would have stopped here as well. Today, the building is home to the Museum of Edgar Allan Poe. (Author.)

The City of Baltimore was granted the authority to tax by the state legislature as early 1750, but many public projects were funded through licensed lotteries. In 1754, a lottery was advertised in Annapolis's *Maryland Gazette* to fund a public wharf in Baltimore. Another advertisement, in 1763, described one to fund a new market house and two fire engines. Lottery offices seemed to be everywhere in the city. (Author.)

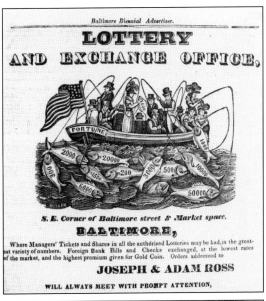

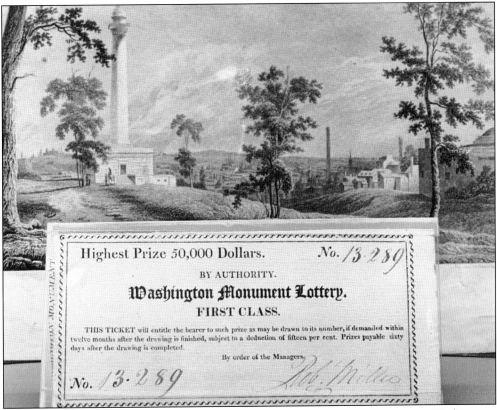

No other civic project received as much goodwill as Baltimore's monument to George Washington. The project was proposed as far back as 1805, but it was not organized until 10 years later. A lottery was created to raise an initial $100,000, but more would be needed. When completed in 1829, the 178-foot marble shaft could be seen from anywhere in Baltimore, including Poe's house on Wilks Street. (*Baltimore Sun*.)

The Merchants Exchange Building was designed by Benjamin Latrobe and opened in June 1820. Fronting on Gay Street, between Lombard and Water Streets, it served at different times as a stock exchange, customshouse, post office, and hall for public ceremonies. It was viewed in Baltimore with much pride. This post–Civil War photograph shows the Lombard Street portico; the horse cart stands on Gay Street. (Author.)

Edgar Allan Poe served in an artillery regiment of the US Army from 1827 to 1829, during which he rose to sergeant major, the highest noncommissioned rank. Wanting to enter West Point, he organized an early discharge by hiring a substitute to finish his term of service, a practice that was then permitted. Poe never deserted from the Army or the US Military Academy. (Author.)

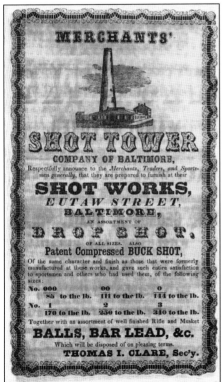

When Edgar Allan Poe lived in Baltimore, there were three shot towers rising up from the city. These facilities produced rifle and canon shot by exposing measures of molten lead to zero gravity; it was the height of technology in the 1820s. Poe lived and walked in the shadow of these towers every day. (Author.)

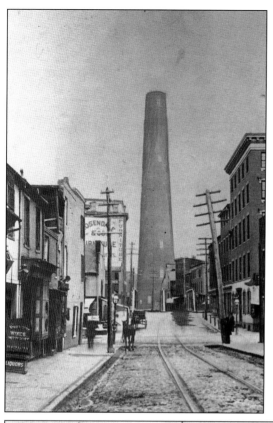

The first Baltimore shot tower was erected in 1823 on Gay Street, north of Fayette Street. It stood until 1845. The second, Phoenix Shot Works, was built to much fanfare in 1828 at the corner of Fayette and Front Streets. At 234 feet, it was then the tallest structure in the nation. The third stack, the property of Gist's Shot Company, stood at Eutaw and Conway Streets. It was said to have been erected to spite the Phoenix's owner, who eventually sold to Gist's (then called Merchant's). The Eutaw Street structure was then dismantled in 1851 and the bricks resold to build five surrounding warehouses. The left photograph, of the Fayette Street tower, was taken after the Civil War and shows misaligned streets between Baltimore and Old Town, and the trellis or "Baltimore" bridge over the Jones Falls. (Left, author; below, Maryland Historical Society.)

Merchants' Shot Company,

COR. FRONT AND FAYETTE STS.

Baltimore, Md.

Having all new and the most approved machinery for the manufacture of Drop and Mould Shot and Bar Lead, the quality of our manufactured articles in sizes, style and finish is not excelled in the world. The sizes of Shot we manufacture are

MOULD SHOT, - - No.	16	37	55	1C	AP	NP	000	00	0	1	2	3
Number to the Pound	16	37	55	212	51	85	85	111	144	170	250	340

Colt's Army. Navy. Pistol. Buck Shot.

DROP SHOT.—TTT TT T BBB BB B 1 2 3 4 5 6 7 8 9 10 11 12 13 14

HENRY D. HARVEY, President. LUCIEN O'CONNOR, Secretary, *pro tem.*

DIRECTORS.

HENRY D. HARVEY,

JAMES HOOPER, Jr., of James Hooper & Sons, | FRANCIS A. CROOK, Treas Balto. Equitable Society,
GEORGE N. EATON, of Eaton Bros. & Co. | WILLIAM WILSON, Jr., of Wilson, Burns & Co.
GEORGE WM. BROWN, late Mayor of Baltimore. | GEORGE W. CORNER, of James Corner & Sons.

Two

PORT IN THE STORM
1829–1830

In 1827, a rupture occurred between Poe and his foster father John Allan over his forced departure from Thomas Jefferson's University of Virginia. Poe left Richmond and the Allan household, probably stopping in Baltimore only briefly while on his way to Boston, a destination offering much distance between him and those who might pursue. In Massachusetts, he published his first volume of poems anonymously and then enlisted in the Army under the name Edgar Perry. After two years in the service and rising to the rank of sergeant major, he secured an honorable discharge. Poe and his foster father had reconciled (somewhat) after the death of Frances Allan and had agreed on Poe's desire to enter the military academy at West Point. His reconciliation with Allan not complete, Poe waited in Baltimore before his admittance. During this time, he established contact with his grandmother's family, ingratiating himself to the extent whereby he acted as his aunt's agent in the transfer of her slave.

When Poe landed in the city, the Baltimore & Ohio Railroad, initially only a horse-drawn streetcar line to Ellicott Mills, was still under construction. A ticket office had been established on Pratt Street in the downtown area, and a full-service depot was started on newly acquired land on the Mount Clare estate at the western edge of the city. Baltimore was also taking much pride in the just-completed Washington Monument north of the city. Many would stroll or take carriage rides up to the country to picnic in the shadow of the giant marble column. When they were not erecting monuments, Baltimoreans were building redbrick houses at the rate of 500 a year between 1824 and 1829. The city's progress at this time could be heard as well as seen.

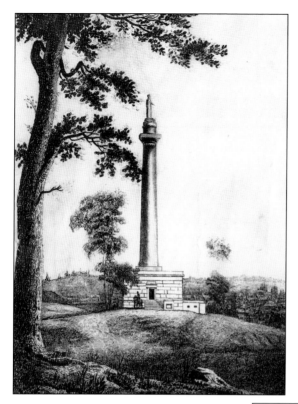

When the Washington Monument was completed in 1829, it stood by itself in the northern countryside. Its location at the lower edge of the forested Howard's Park, with no nearby structures, was considered remote; the road to it from the city was not yet paved. William Wirt would call it "indescribably striking from the touching solitude of the scene from which it lifts its head." (Author.)

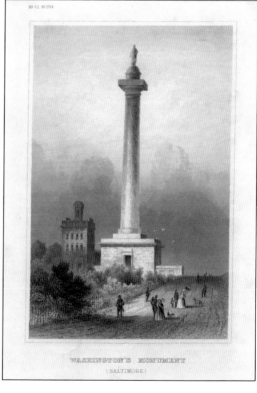

WASHINGTON'S MONUMENT
[BALTIMORE]

The completed monument was almost immediately swarmed by the prestigious houses of Baltimore's affluent. In Poe's funny, futuristic tale "Mellonta Tauta," he ridicules the inability of New York City's affluent to raise a similar monument. (Author.)

This page, removed from the poetry album of socialite Lucy Holmes Balderston, contains one of Poe's most memorable poems. Written in 1829 while he was staying in Baltimore, the piece clearly shows that he was still under the spell of Lord Byron. The work was discovered in 1875 by Eugene Didier, who took it upon himself to change the title to "Alone" from the declarative heading "Original." (Maryland Historical Society.)

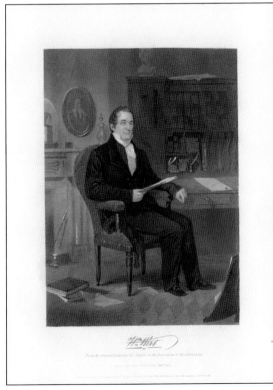

Poe was shopping his epic poem "Al Aaraaf" for evaluation or publication to anyone he could find, including William Wirt, novelist, biographer, and the longest-serving US attorney general, who was then living in Baltimore. The poem baffled Wirt, who wrote to Poe that "I should doubt whether the poem will take with old-fashioned readers like myself." Wirt still referred Poe to a couple of magazine editors. (Author.)

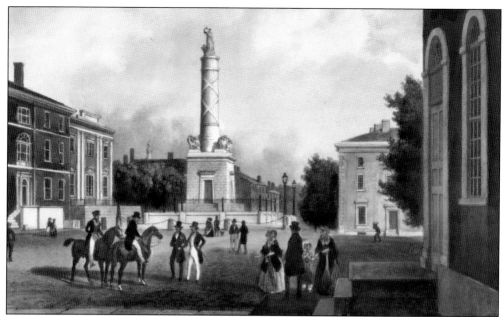

The district around Monument Square on Calvert Street was the most desirable residential property in Baltimore until the erection of the Washington Monument in 1829. William Wirt had a townhouse just a few doors north of the square on Calvert Street. Poe visited him there several times. (Author.)

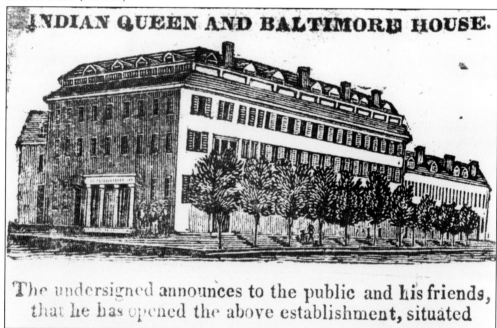

INDIAN QUEEN AND BALTIMORE HOUSE.

The undersigned announces to the public and his friends, that he has opened the above establishment, situated

William Beltzhoover took over operation of the old Indian Queen Hotel from 1826 to 1832. It was the same building where Francis Scott Key wrote "The Star-Spangled Banner." While sharing a room with his cousin James Mosher Poe, Edgar Poe claimed (in a letter to John Allan) to have been robbed of $46 by James. For unknown reasons, Poe identifies his cousin as "Edward Mosher." (Author.)

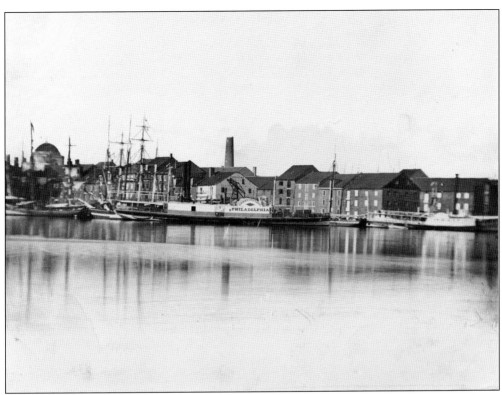

During Poe's time, Baltimore was a seaport, first and foremost. This northern view of the harbor shows both steamers and sailboats; behind them are warehouses and merchant buildings on the piers, as well as the Exchange Building and the Shot Tower on Fayette Street. Poe lived just four blocks north of this area, on Wilks Street, in what is today Little Italy. (*Baltimore Sun*.)

Maria (pronounced "Mariah") Clemm was the sister of Edgar Allan Poe's father. During the eight-month period that Poe stayed in Baltimore in 1829, she was living with and nursing her mother, Poe's grandmother Elizabeth Poe, who was paralyzed and bedridden. "Muddy," as Poe called Maria, would become his mother-in-law when he married her daughter (his first cousin) Virginia Clemm. (Enoch Pratt Free Library.)

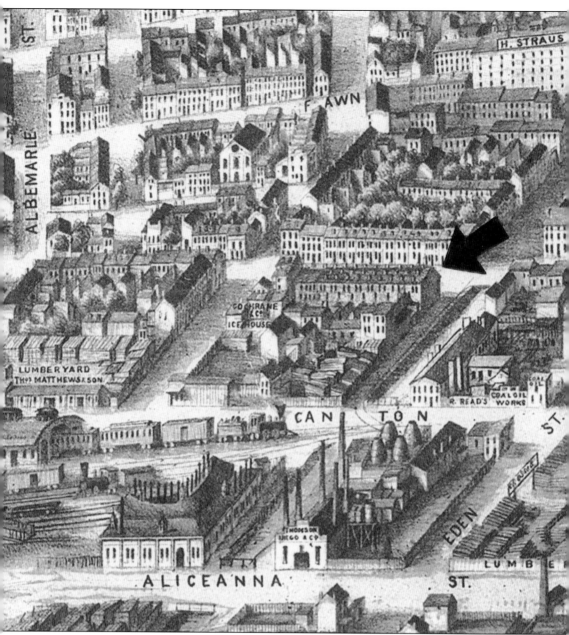

In 1829, the Clemm-Poe household was residing in a Federal-style row house known as Mechanic's Row. In this close-up of *E. Sachse's Bird's Eye View of the City at Baltimore in 1869*, the building can be seen just above and to the right of Cochrane's Icehouse at center. Mechanic's Row is on the south side of Wilks Street (now Eastern Avenue). In their research for the Maryland Historical Society in 1991, Mary Markey and Dean Krimmel established the structure's location and the Clemms' residence as probably the last address on the eastern end of the row. Harford Run had by this time been reduced to a canal and passed directly by their end of the building. In this area, the canal had not yet been covered and was, for all purposes, an open sewer. This may have been the actual reason for the family's move to Amity Street. (Enoch Pratt Free Library.)

With the help of John Allan, Poe won a cadetship at the military academy at West Point and, in 1829, was waiting in Baltimore prior to entry. When the process dragged, Poe claimed in a letter to Allan that he walked to Washington, DC, to meet with Secretary of War John H. Eaton (pictured) in an attempt to expedite the procedure. During the interview with Eaton, Poe was told that he was still 10th on the list, after which he returned to Baltimore "on foot." On his trek to and from the capital on what is today US Route 1, Poe would have been passed by the regularly running stagecoaches that serviced the Baltimore-Washington corridor. If only he could have come up with the fare to ride on one! (Both, author.)

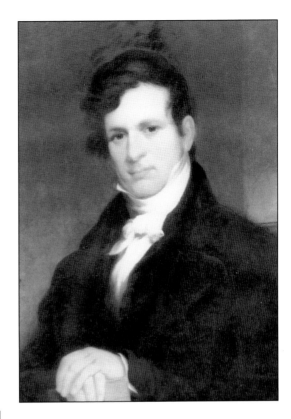

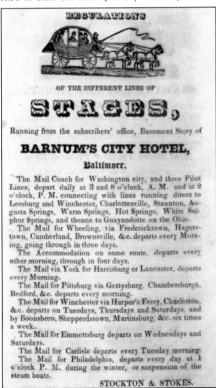

REGULATIONS

OF THE DIFFERENT LINES OF

STAGES,

Running from the subscribers' office, Basement Story of

BARNUM'S CITY HOTEL,

Baltimore.

The Mail Coach for Washington city, and three Pilot Lines, depart daily at 3 and 8 o'clock, A. M. and at 2 o'clock, P. M. connecting with lines running direct to Leesburg and Winchester, Charlottesville, Staunton, Augusta Springs, Warm Springs, Hot Springs, White Sulphur Springs, and thence to Guayandotte on the Ohio.

The Mail for Wheeling, via Fredericktown, Hagerstown, Cumberland, Brownsville, &c. departs every Morning, going through in three days.

The Accommodation on same route, departs every other morning, through in four days.

The Mail via York for Harrisburg or Lancaster, departs every Morning.

The Mail for Pittsburg via Gettysburg, Chambersburgh, Bedford, &c. departs every morning.

The Mail for Winchester via Harper's Ferry, Charleston, &c. departs on Tuesdays, Thursdays and Saturdays, and by Boonsboro, Shepperdstown, Martinsburg, &c. six times a week.

The Mail for Emmettsburg departs on Wednesdays and Saturdays.

The Mail for Carlisle departs every Tuesday morning.

The Mail for Philadelphia, departs every day at 1 o'clock P. M. during the winter, or suspension of the steam boats.

STOCKTON & STOKES.

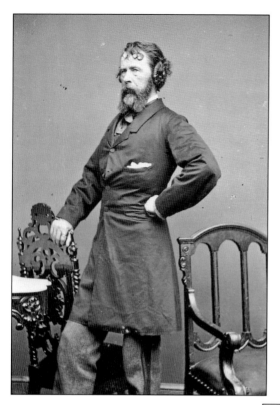

Nathaniel Parker Willis is shown here in the 1860s. When publicly rejecting Poe's poem "Fairyland" for the November 1829 edition of *American Monthly Magazine*, Willis claimed that the poem warmed him, especially after he tossed it into the stove. Willis would come to recognize Poe's genius and, after Poe's death, was one of his staunchest defenders. (Library of Congress.)

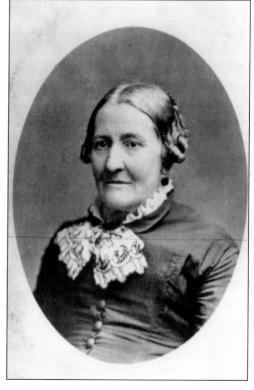

Elizabeth Rebecca Herring was Edgar Allan Poe's first cousin. As a young girl, she was said to be stunningly attractive. In 1829, Poe wrote two acrostic poems in her album, the first letter of each line spelling her name. She traveled all the way to New York to visit Edgar and his wife during the final days of Virginia's life. (Johns Hopkins University.)

One enduring bit of Baltimore lore tells of a poetry contest between Poe and John Lofland (pictured), the "Milford Bard," who claimed he could write more verse in a given time. The legend is that Lofland won the competition by just throwing rhymes together, while Poe tried to construct genuine poetry. It is not clear where the contest actually took place, but in both accounts, the loser, Poe, had to buy drinks at the Seven Stars Inn. The tavern was the gathering place for a clique of bohemian writers and editors of the city, as well as the first "lodge" for the Independent Order of Odd Fellows. When this rendering was made (below), water from the harbor still reached up as far as "Water" Street and can be seen just to the left of the building. (Right, John Hopkins University; below, author.)

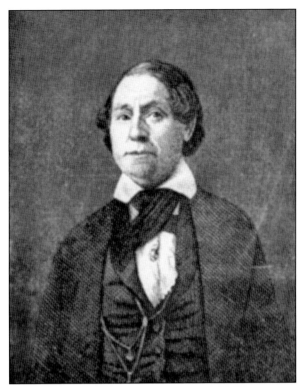

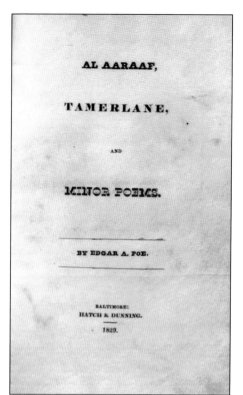

Poe's second book of poems, *Al Aaraaf, Tamerlane, and Minor Poems,* was finally published by Hatch & Dunning in Baltimore late in 1829 and contained a revised version of the mammoth poem. He dedicated the work to his mentor, John Neal. The collection got noticed, but, like his earlier book, brought Poe little or no remuneration. (Author.)

Poe left Baltimore early in January 1830 and repaired to Richmond in preparation for his entry to the military academy. At West Point, Poe felt out of place; "Old-P" was much older than most of the cadets, and the rigidity there chafed his sensitive nature. He engineered his own dismissal and left the academy in March 1831. It was the last straw with John Allan. (Johns Hopkins University.)

Three

POET IN MOB TOWN
1831–1835

When Edgar Allan Poe returned to Baltimore in 1831, he had no credentials, trade skills, or prospects for employment. It appears he immediately took up residence with the Clemm-Poe household on Wilks Street, which consisted of Elizabeth Poe, his bedridden grandmother; Maria Clemm and her two children, Virginia and Henry; and Edgar's older brother, William Henry Leonard Poe. A female slave is also listed as a household member in the census. Including Edgar, seven people lived in what would be described today as a top-floor apartment of probably no more than 750 square feet. William "Henry" Poe died in August 1831; in November, Edgar may have been jailed for nonpayment of a note he cosigned on Henry's behalf. The recurring outbreak of cholera and proximity to what was an open sewer may have prompted the family's relocation around 1833 to a newly built house at 3 Amity Street in the western precincts of the city of Baltimore. There, Poe continued to write and submit his work to various magazines while tutoring his 10-year-old cousin Virginia. In October of that year, Poe won a cash prize for a tale submitted to the *Baltimore Saturday Visiter*, marking the first time he was paid for any of his compositions. As a direct result, he befriended John Pendleton Kennedy, one of the contest judges, who acted as mentor and patron for the unknown writer, arranging his first full-time literary employment with the *Southern Literary Messenger* in Richmond, Virginia. After Poe's grandmother died that summer, he left for Richmond during a four-day riot that was the worst in Baltimore's history.

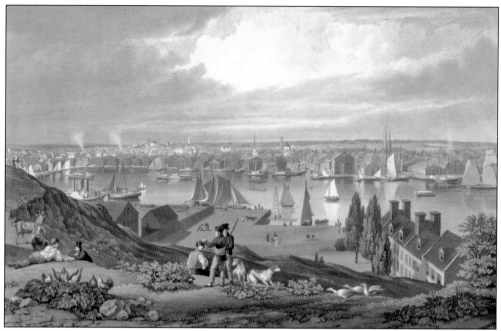

This somewhat pastoral view of Baltimore from Federal Hill in the 1830s shows a busy city and its major landmarks. Sailed ships now had to share the harbor with steam-powered vessels, and the effects of decades of mining Federal Hill of fill dirt for the waterfront can also be seen. (Library of Congress.)

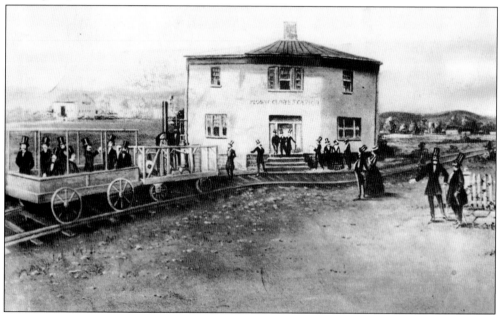

The first railroad depot in Baltimore was actually on Pratt Street, one block west of Light Street. When steam locomotives were later planned, a second station was established farther west on Pratt Street, which would keep the noisy devices out of town. Although trains were using the Mount Clare location in the 1830s, the structure depicted here may not have been built until after Poe's time in Baltimore. (Author.)

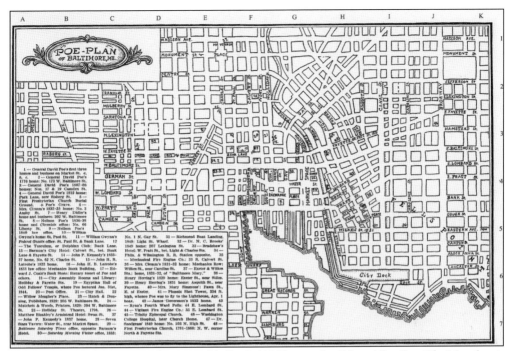

This Poe-themed map is used in Mary Phillips's 1926 biography *Edgar Allan Poe: The Man*, but it contains several mistakes. Incorrect locations are shown for the Poe-Clemm house on Amity Street, Barnum's City Hotel, and John Pendleton Kennedy's 1837 house. (Edgar Allan Poe Society.)

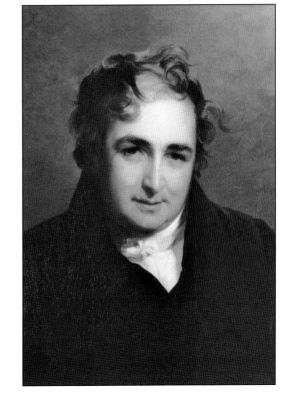

Irish-born William Gwynn was a lawyer who, in 1812, took control of the *Federal Gazette and Baltimore Daily Advertiser* from John Hewes. Gwynn was still editing the paper when Poe wrote to him in 1831, applying for the editorial job vacated by his cousin Neilson Poe. In his letter, Edgar Poe is apologetic, alluding to his misbehavior in an earlier affair. He did not get the job. (Author.)

41

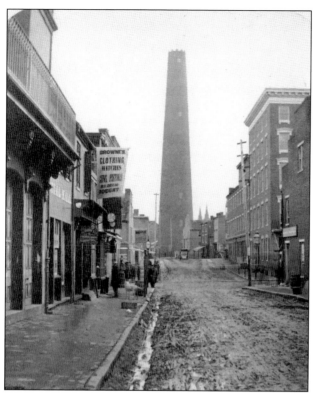

Another Baltimore legend involving Edgar Allan Poe is an April Fools' Day hoax in which he announced (anonymously) in a Baltimore paper that a man would fly from the top of the Phoenix Shot Tower on Fayette Street (left) to the newly built lighthouse at Lazaretto Point (below), two miles away. The story goes that Poe crafted an ingenious advertisement, with many people swallowing it whole. They gathered to witness the event, only to turn into an angry mob when finally realizing the deception. The crowd then thronged the newspaper office. The publication was said to be William Gwynn's *Gazette*, and the hoax is believed to be the "misbehavior" that Poe mentions in his letter to Gwynn. However, no further evidence has been found to support the story. (Both, Maryland Historical Society.)

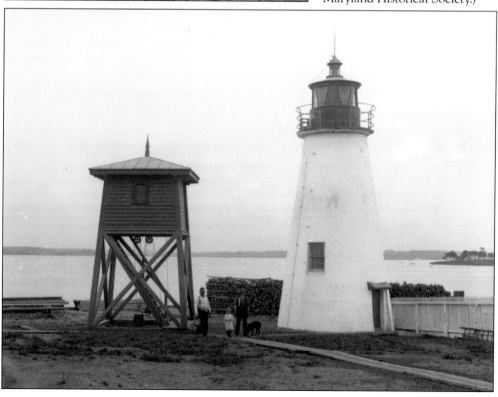

This romantic view of Baltimore, looking down the Jones Falls from what is now Chase Street, allows a sense of the original topography of the east side of the city. One can also see the Fayette Street and Gay Street Shot Towers, and between them, the old city jail above Monument Street. Poe claimed that he was an inmate there for a short time in 1831. (Library of Congress.)

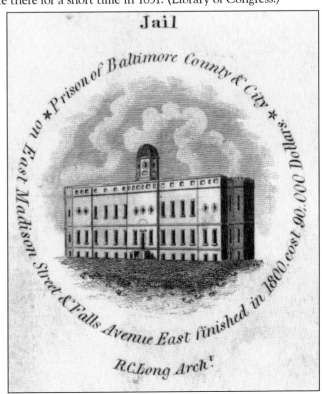

The city of Baltimore's first jail, depicted here, was built in 1801 and remained in use until a grander facility was built in 1859. In November 1831, Poe wrote to John Allan to say he had been arrested for an unpaid debt that he shared with his recently departed brother Henry. Poe was begging for $80. Growing insensitive to these regularly occurring entreaties, Allan would be slow to respond. (Maryland Historical Society.)

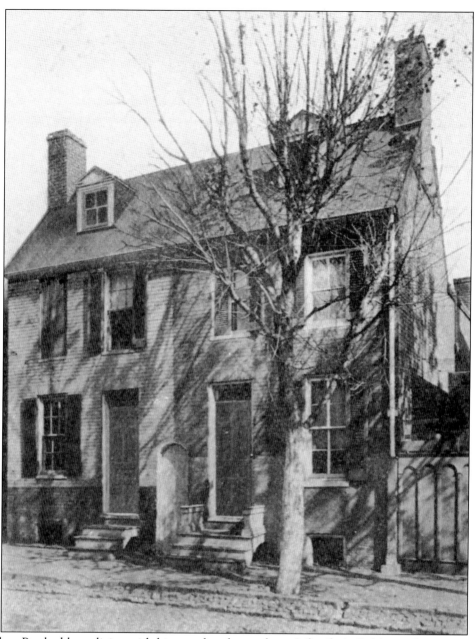

Edgar Poe had been living with his grandmother and aunt's family in Baltimore for two years when they moved to this small house at 3 North Amity Street. Its location was then termed the "Western Precincts," but, in reality, it was the absolute western edge of town. Maria Clemm moved her family by 1833, perhaps a year or more after the attached houses were completed. It is not known if they were the first tenants. Although gas service had begun in the center of the city, infrastructure to the western extremities would be many years away. Lamp oil cost money, so, at night, Poe coercively wrote by candlelight. Water for bathing, cooking, and cleaning had to be retrieved, perhaps from a well in the "neighborhood" or Schroeder's Run about 150 yards west of the house. This is the only known photograph of the duplex as it appeared in Poe's time. (Edgar Allan Poe Society.)

This incorrect drawing of Amity Street, created by Raphael Weed for Mary Phillips's 1926 biography of Poe, is based on logical assumptions but little or no research. The street numbers on the attached houses were actually 3 and 5, No. 1 being assigned to the building immediately below (indicated as the "Paint Shop") that had a residential entrance on Amity Street. (Edgar Allan Poe Society.)

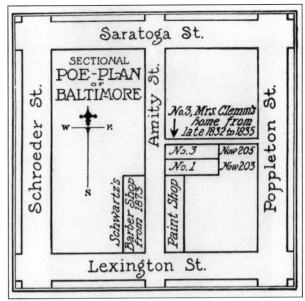

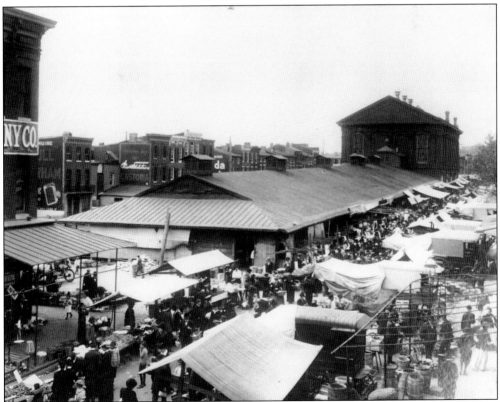

The market on Hollins Street was well established when the Clemm-Poe family lived just five blocks north on Amity Street. The city-sponsored Lexington Market would have provided a better selection, but it was twice the distance from their house. Like most markets in the city of Baltimore at that time, Hollins Market was open two days a week, but kept afternoon hours only. The market is seen here in the early 1900s. (Author.)

45

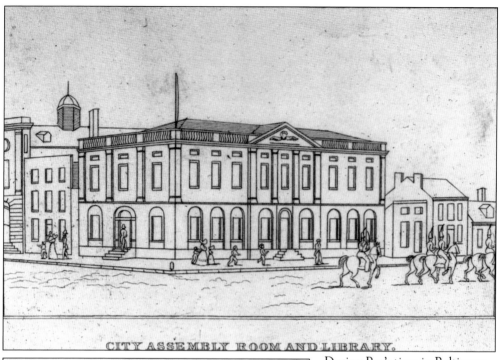

CITY ASSEMBLY ROOM AND LIBRARY.

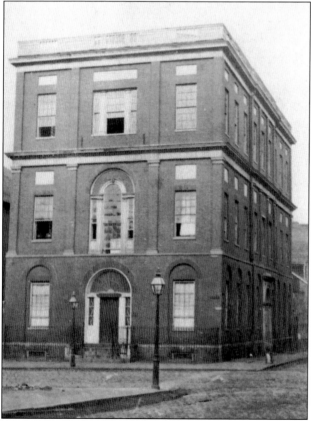

During Poe's time in Baltimore, there were two "public" libraries. The first, and probably most frequented by him, was the Baltimore Library Company, located in the City Assembly Room building at the corner of Fayette and Holliday Streets. The library was said to be of moderate size with a dignified setting. The Mercantile Library Association was the newer of the two. It began in an upper level of a store opposite the old Indian Queen Hotel. It would eventually move to this building also. Shown here are two views of the City Assembly Room building. The photograph at left was taken after a third story was added, when it housed the Baltimore High School, of which Nathan C. Brooks served as principal until 1849. The building was destroyed in the fire that consumed the nearby Holliday Street Theater in 1873. (Both, Maryland Historical Society.)

Lambert A. Wilmer began his literary career in Baltimore and was an intimate of both Edgar and Henry Poe until the early 1830s. He was replaced as editor of the *Baltimore Saturday Visiter* by John Hewitt, who reportedly offered to do the job for free. After Poe discovered Wilmer's remarks about his drinking, the two hardly spoke again. Wilmer defended Poe vigorously after Poe's death. (Johns Hopkins University.)

Lambert A. Wilmer.

Charles F. Cloud (pictured) had started the *Baltimore Saturday Visiter* in early 1832 as a weekly literary magazine with Poe's friend Lambert Wilmer as editor. By the following year, Cloud had taken on William P. Pouder (pronounced "Pooder") as a partner and replaced Wilmer with John Hewitt. In June, the magazine announced a poetry and short story contest that would pluck Poe from obscurity. (Enoch Pratt Free Library.)

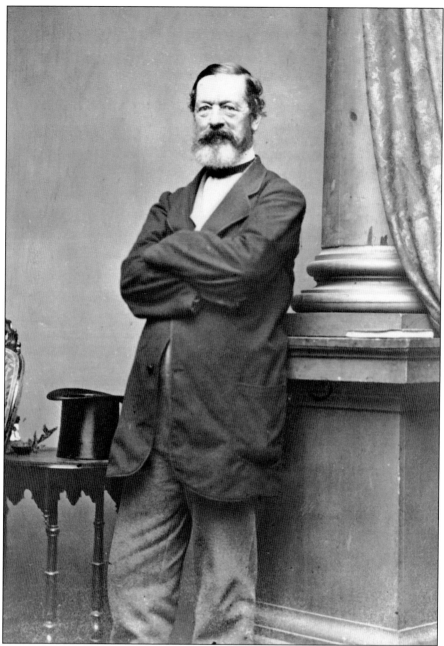

John H.B. Latrobe was one of three gentlemen, along with John Pendleton Kennedy and Dr. James H. Miller, appointed by the *Baltimore Saturday Visiter* to evaluate and select the winning compositions for its literary contest. They met at Latrobe's townhouse at 11 East Mulberry Street in Baltimore (the building survives but is today a private residence). The tradition is that Latrobe selected Poe's tale from the batch he was reading and recited it aloud to the other two panel members. Poe's handwriting was so neat when compared to the other submissions that the judges later joked that they awarded the prize to the "first geniuses who had been known to write legibly." Rufus Griswold, in his disparaging memoir of Poe, would portray the playful remark as fact. (Library of Congress.)

On October 12, 1833, Edgar Allan Poe was awarded a $50 prize by the *Baltimore Saturday Visiter* for his tale "MS. Found in a Bottle"; it was published in the paper the following week. This marks the first time that he received money for any of his productions and the beginning of his professional literary career. Baltimore was the city that discovered him. (University of Texas at Austin.)

The following is the Tale to which the Premium of Fifty Dollars has been awarded by the Committee. It will be found highly graphic in its style of composition.

PRIZE TALE.

BY EDGAR A. POE.

MS. FOUND IN A BOTTLE.

A wet sheet and a flowing sea.
CUNNINGHAM.

Of my country and of my family I have little to say. Ill usage and length of years have driven me from the one and estranged me from the other. Hereditary wealth afforded me an education of no common order, and a contemplative turn of mind enabled me to methodize the stores which early study very diligently garnered up. Beyond all things the works of the German moralists gave me great delight; not from any ill-advised admiration of their eloquent madness, but from the ease with which my habits of rigid thought enabled me to detect their falsities. I have often been reproached with the aridity of my genius—a deficiency of imagination has been imputed to me as a crime—and the Pyrrhenism of my opinions has at all times rendered me notorious. Indeed a strong relish for physical philosophy has, I fear, tinctured my mind with a very common error of this age—I mean the habit of referring occurrences even the least susceptible of such reference, to the principles of that science. Upon the whole no person could be less liable than myself to be led away from the severe precincts of truth by the ignes fatui of superstition. I have thought proper to premise thus much lest the incredible tale I have to tell should be considered rather the ravings of a crude imagination, than the positive experience of a mind to which the reve

Poe's prizewinning tale was written while he resided in Baltimore, probably in 1832. As T.O. Mabbott points out, had it been among his submissions to the *Philadelphia Saturday Courier* contest in 1831, it would almost certainly have been published, winner or not. The story combines the superstition of the Flying Dutchmen and an idea that the earth was hollow. (University of Texas at Austin.)

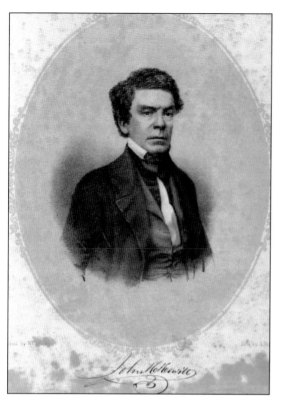

John H. Hewitt (pictured) was a songwriter and an editor of the *Baltimore Minerva and Emerald*, a weekly newspaper, when it carried an unfavorable review of Poe's book *Al Aaraaf, Tamerlane, and Minor Poems*. Poe, ever sensitive to criticism, took it personally. After Poe became famous, Hewitt denied authorship of the review. (Library of Congress.)

In lieu of cash, the *Baltimore Saturday Visiter* offered the winners of its literary contest an award in silver (Hewitt's cup is shown). John Hewitt, the paper's editor, had submitted his poem "The Song of the Wind" under the pseudonym Henry Wilton. When Poe learned that his poem "The Coliseum" may have been the first choice, he confronted Hewitt. By one account, they came to blows. (Johns Hopkins University.)

The most important outcome for Poe of the *Saturday Visiter* contest was the patronage and friendship it brought from Baltimorean John Pendleton Kennedy, one of the contest judges and by then a well-known novelist. Kennedy recognized Poe's genius and was instrumental in arranging his first regular employment with the *Southern Literary Messenger.* This portrait of Kennedy was made in 1825. (*Baltimore Sun.*)

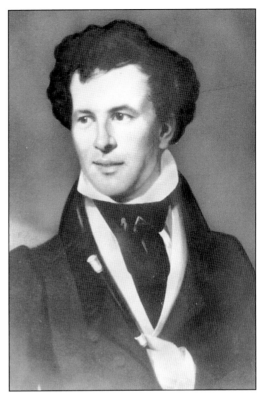

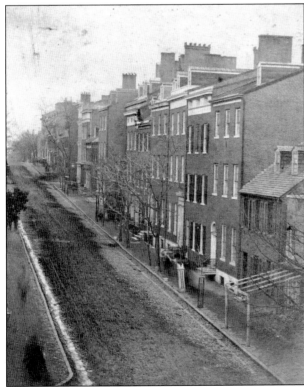

In 1833, John Pendleton Kennedy was living in the fashionable neighborhood of North Charles Street, now the 300 block. He would eventually take over William Wirt's house just above Monument Square on Calvert Street. Edgar Allan Poe visited both addresses of his friend and mentor. (Maryland Historical Society.)

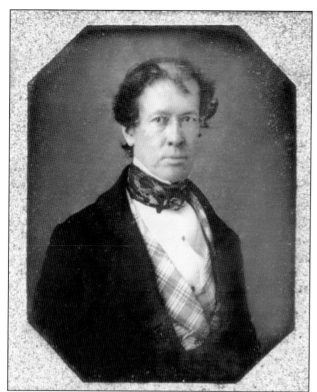

This rare photographic image of John Pendleton Kennedy was taken during Poe's time. It shows him in fashionable dress and with a hairstyle that seems unkempt but was actually the contemporary trend. Poe would say to Kennedy, "Without your timely aid I should have sunk under my trails." (Poe Baltimore.)

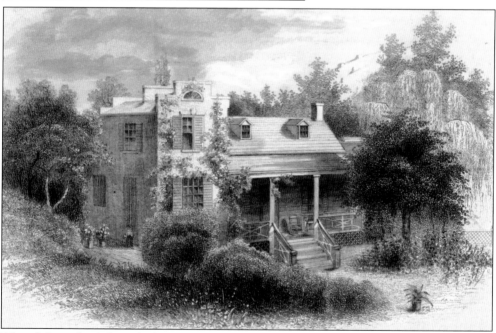

Edward Gray, the father of John P. Kennedy's wife, owned a cotton-spinning factory at Ellicott Mills on the Patapsco River, eight miles west of Baltimore. Kennedy and his family would use his cottage (pictured) as a summer retreat from the sizzling and foul-smelling city. Poe is believed to have traveled there by train at least once. (Enoch Pratt Free Library.)

Before *Ripley's Believe It or Not!*, there was the Baltimore Museum, established in 1829 by Rembrandt Peale to replace his museum building on Holliday Street that was serving as Baltimore City Hall. It was a Baltimore landmark until being destroyed by fire in 1872. (Author.)

BALTIMORE

MUSEUM,

AND GALLERY OF FINE ARTS,

CORNER OF BALTIMORE & CALVERT STS.

This institution contains a valuable collection of Natural History, viz. Quadrupeds, Birds, Fishes, Turtles, Lizards, Snakes, Insects, Shells, Corals, Minerals, and the

Stupendous Skeleton of the Mammoth,

Which was dug out of a morass in Orange county, State of New York; Indian Curiosities, Implements of War, Agriculture, and Dresses of various Nations, besides a large collection of miscellaneous articles.—Also, a valuable

GALLERY OF PAINTINGS,

BUSTS, MEDALLIONS, COINS, MEDALS, &c.

The Museum is always open to visiters, from sun-rise to 10 o'clock at night;—it is BRILLIANTLY ILLUMINATED every evening with Gas lights, and in the course of the evening, a rich display of

Philosophical Experiments,

Are exhibited in the Lecture Room, in some one of the following branches, viz. Chemistry, Pneumatics, Electricity, Galvanism, Magnetism, Chinese Shades, Transparencies; and the Magic Lantern, which has attached to it a complete set of Astronomical Slides.

MEDICAL ELECTRICITY is judiciously administered.

PROFILES cut and framed as usual.

☞ Subjects of Natural History put up in the best manner for exportation.

Admittance at all times, 25 cents, children half price.

N. B. No extra charge will be imposed at any time on annual subscribers hereafter. J. E. WALKER.

In May 1834, a well-advertised balloon ascension was staged on the far eastern side of the city at Fairmount Park. If he did not attend, Poe certainly knew of the event, as his uncle Henry Herring is reported to have constructed a great wooden amphitheater for the crowd. This image shows the Fairmount Hotel and unobstructed views of the city before the Washington College Hospital building was erected. (Author.)

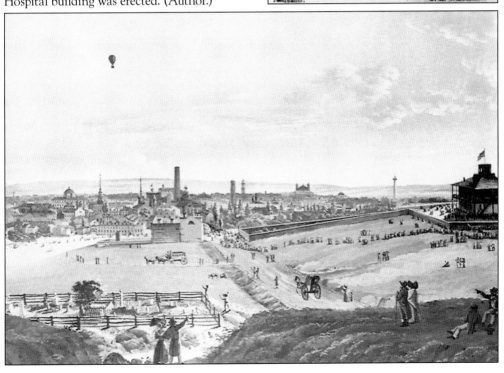

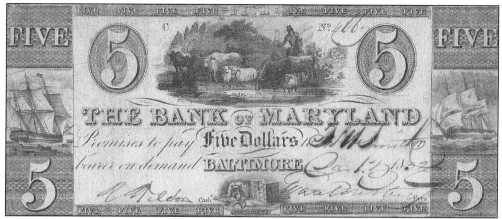

Nicknamed "Mob Town" early in the 19th century, Baltimore had acquired a lawless reputation. One of the city's worst spectacles took place in August 1835 after the failure of the Bank of Maryland (a year earlier) and following newspaper reports that the officials responsible would not only escape punishment but had profited from the collapse. Mercifully, Poe would be holding few of these banknotes at the time. (Author.)

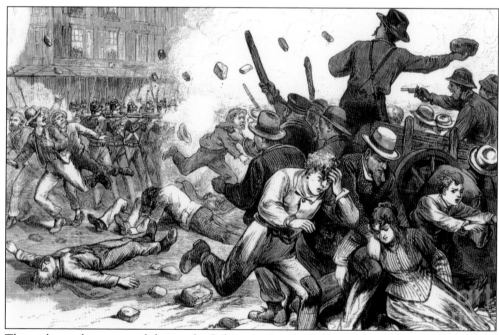

The violence that occurred during the Baltimore riots in 1835 was directed at the homes and property of the former bank officials. The smashing of windows quickly escalated to the burning of houses; other structures were spared and bonfires made of their contents. Mobs roamed the city without check, and Mayor Jesse Hunt would resign in disgrace. Poe's house on Amity Street, almost two miles away, was unaffected. (Author.)

When bank directors Judge John Glenn and Reverdy Johnson (shown here later in life) issued a pamphlet that threw the blame on the Bank of Maryland's administrator, Evan Poultney, the public became even more incensed and targeted the homes belonging to the directors. Glenn's home on Charles Street was the first to be stormed. Johnson was out of town when the rioters pushed passed the mounted guard provided by Mayor Hunt and broke into his fine mansion on Calvert Street (depicted below). As his structure was built against another's who was not involved, the crowd instead gutted the interior and illuminated the Battle Monument outside with a blaze made from Johnson's exquisite furniture and legal library. Johnson would survive the scandal and go on to have a remarkable career in Washington, DC. (Both, author.)

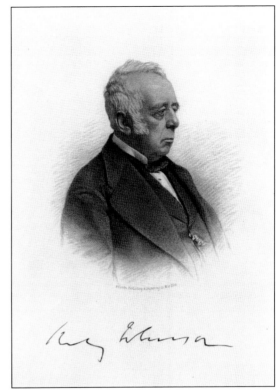

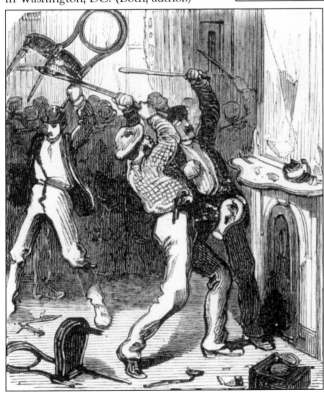

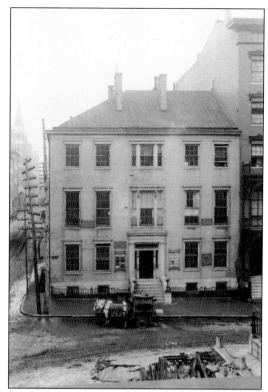

After the Baltimore bank riots in 1835, the large house on the northwest corner of Calvert and Fayette Streets would always be known as the "Reverdy Johnson House." This photograph of the townhouse was taken many years after Gen. Samuel Smith and a large force of volunteers restored order to the city, but not before six mansions were destroyed and as many as 22 people killed. (Maryland Historical Society.)

The buildings shown in this turn-of-the-century view of Monument Square had not changed significantly from the days of unrest in 1835. Behind the Battle Monument are the Reverdy Johnson House, adjacent hotel, and city/county courthouse. Poe left for Richmond and an engagement with the *Southern Literary Messenger* at the time of the Baltimore bank riots. He would return in September to collect Virginia and Mrs. Clemm. (Author.)

This image of Edgar's second cousin Neilson (pronounced "Nelson") Poe is believed to have been made when he was 34 years old. Poe called him his "bitterest enemy in the world," probably because of Neilson's interference with Edgar's plan to marry his cousin Virginia Clemm. Both would come to soften their opinions of the other. (Edgar Allan Poe Museum.)

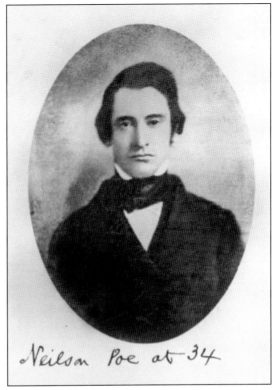

Neilson Poe at 34

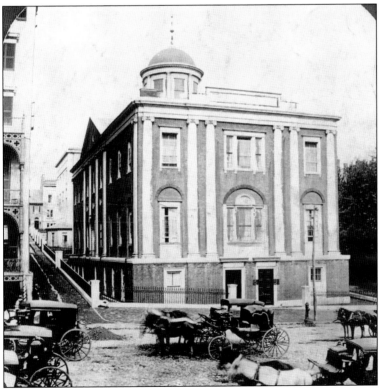

According to Neilson Poe and Maria Clemm, Edgar and his cousin Virginia secretly wed before leaving Baltimore in 1835. Although there is a record of the wedding license, some Poe scholars are incredulous that it happened. If Poe did marry Virginia while still in Baltimore, he would have had to visit this city/county courthouse building on Monument Square, being rebuilt at the time from a disastrous fire. (Author.)

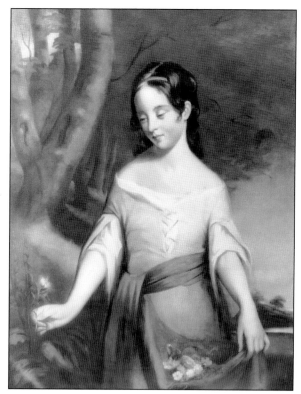

It was not uncommon for 13-year-old girls to marry, or to marry their cousins, in the early 19th century. But the Poes were sensitive to the age difference between Virginia and Edgar, who was 26. Listing the age of the girl in this portrait (of questionable provenance) as 21 on a second marriage license in Richmond, Virginia, must have raised some eyebrows. However, the image of Poe (below), painted at a later time by John A. McDougall, is a reminder of how youthful he must have appeared when he married her. It is not hard to imagine the attraction there must have been between them. (Left, Enoch Pratt Free Library; below, author.)

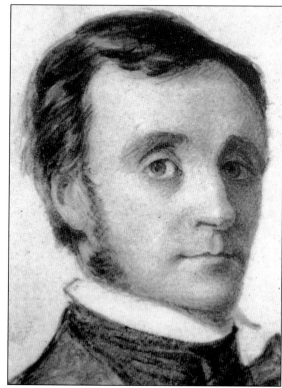

Four

ANTEBELLUM BALTIMORE
1836–1848

When Edgar Allan Poe moved to Richmond, Virginia, in the fall of 1835, he would never return to live in Baltimore again. After serving an 18-month stretch as "assistant" editor and contributor for the *Southern Literary Messenger,* he traveled first to New York. Unable to find expected editorial opportunities, he and his small family of three settled in Philadelphia, where he was to live until 1844. Poe's time there would be the longest he would spend in any city after leaving Baltimore. It was his most prolific period, during which he wrote most of his best-known works. After their time in Philadelphia, the Poe-Clemm family moved back to New York, where they would have as many nine different addresses, the last being a small cottage at Fordham (now the Bronx). While in that city, Poe published "The Raven" and became a national sensation, but, as there were then no copyright laws, the stardom he enjoyed was attended by no direct financial reward. The degree of poverty suffered by Poe and his family at Fordham is difficult to read about, even today.

Poe returned to Baltimore in 1844, to give a lecture at the Odd Fellows Hall on Gay Street, and again perhaps for several personal visits, including one in 1847 after his wife, Virginia, died. The city he encountered was now connected to New York by rail. Upon disembarkation, the traveler had a choice of many fine hotels, including the National and United States Hotels on Pratt Street, as well as the Fountain Inn and Barnum's City Hotel nearby. It is believed that Poe stayed with the Herrings when he visited.

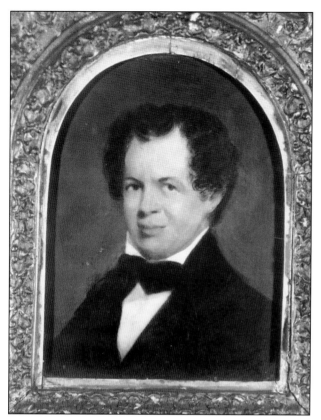

Thomas Willis White began the *Southern Literary Messenger* in August 1834 in Richmond, Virginia, but he had to rely on others for editorial guidance. He paid Poe $10 a week plus contributions by the piece. Although White was uncomfortable with Poe's caustic and often personal style of literary criticism, subscriptions to the periodical had quintupled by the time Poe departed in 1837. (Edgar Allan Poe Museum.)

Edgar Allan Poe settled in Philadelphia in early 1838 after a vexing 11 months in New York City. His six years in Philadelphia were his most productive, when he penned his most well-known tales. This house at Seventh Street and Spring Garden is believed to be the last home of Poe and his family while in the city. Today, it is maintained by the National Park Service. (Johns Hopkins University.)

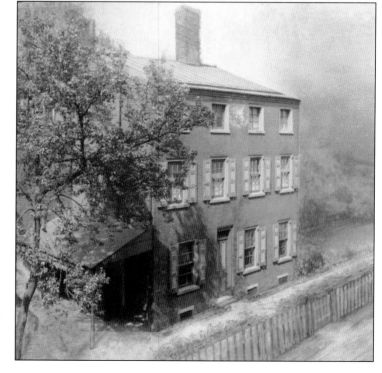

Nathan C. Brooks had been a teacher and educator at several institutions in Maryland when, along with Joseph Snodgrass, he started *American Museum* magazine in September 1838. It is believed that Poe visited Baltimore that summer, during which Brooks asked him for a contribution to his forthcoming publication. Poe may have also met with his cousin Neilson Poe, who was then editing the *Baltimore Chronicle*. (Author.)

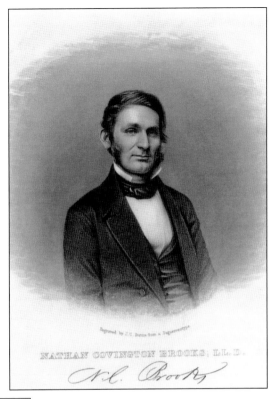

NATHAN COVINGTON BROOKS, LL.D.

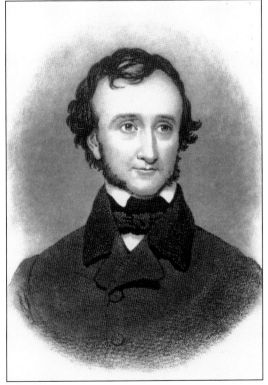

This engraving of Edgar Allan Poe was done by his friend John Sartain, who recalled coming to Poe's aid when he was stricken in Philadelphia during his final trip in 1849. In this account, Poe was delusional and, thinking he was being pursued, sought a razor to remove his mustache to affect a disguise. Not trusting Poe with a razor, Sartain claims to have shorn him with scissors. (Author.)

There are several stories of visits by Poe to Baltimore in the late 1840s, one of which may be confirmed by a letter from Mary Hewitt to Poe dated April 5, 1846. Other accounts, having him indulging at Guy's Monument House (shown here later), are less believable. Guy also operated the United States Hotel on Pratt Street, which included an oyster bar during Poe's time. (Author.)

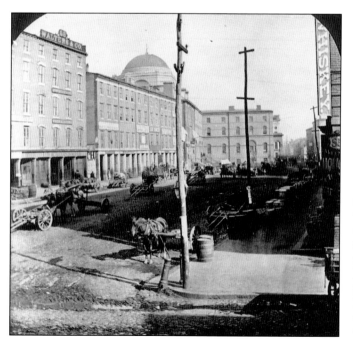

Baltimore in the 1840s was a giant engine of activity and industry. In this later view of Exchange Place on East Lombard Street, it appears the paved street is in need of cleaning. The Exchange Building and its rotunda still dominated Poe's old neighborhood when this photograph was taken. (Author.)

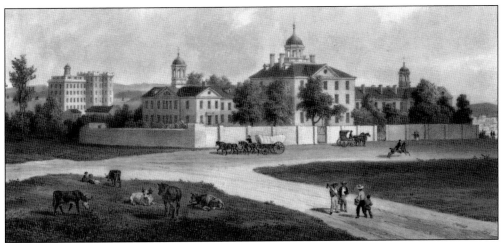

In the 1840s, the Maryland Hospital was a psychiatric facility that occupied the site where the Johns Hopkins medical complex is today. According to Baltimore historian Sherry Olson, "Maniacs and diseased persons were sent there by the city at fixed rates for long term care." In 1849, when Poe was found on Lombard Street, he was sent to a separate, public hospital, seen here in the background. (Enoch Pratt Free Library.)

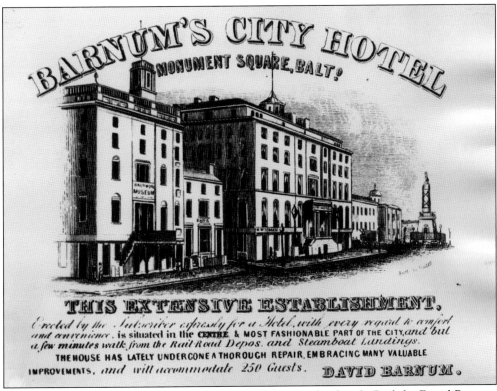

The City Hotel was a well-known 19th-century Baltimore landmark. Built by David Barnum in 1826 on the southwest corner of Calvert and Fayette Streets, it boasted the most luxurious accommodations in town. This 1840s advertisement shows the building in its original form, with five floors, as well as its proximity to Monument Square and the Baltimore Museum. (Author.)

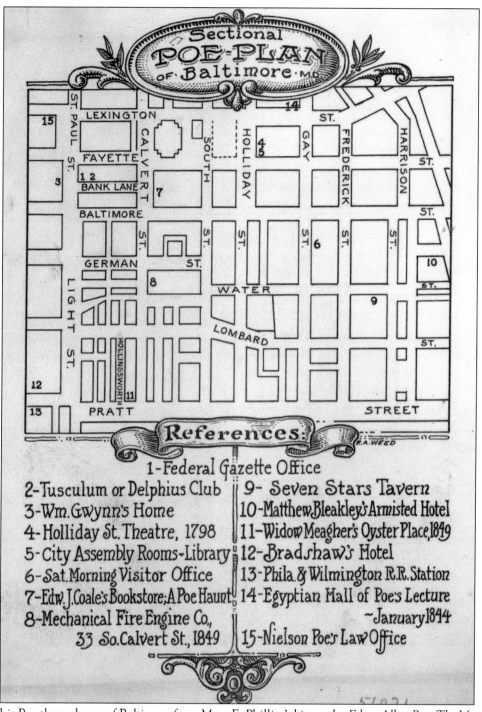

Sectional
POE-PLAN
of Baltimore, MD.

LEXINGTON ST.
15
ST. PAUL ST.
CALVERT ST.
14
SOUTH ST.
HOLLIDAY ST.
4
5
GAY ST.
FREDERICK ST.
HARRISON ST.

FAYETTE
1 2
3
BANK LANE
7
ST.
BALTIMORE
ST. ST. ST. ST. ST.
6
ST.
GERMAN ST.
LIGHT ST.
8
WATER
10
ST.
9
HOLLINGSWORTH
LOMBARD
ST.
12
11
13
PRATT STREET

R.A.WEED

References

1—Federal Gazette Office
2—Tusculum or Delphius Club
3—Wm. Gwynn's Home
4—Holliday St. Theatre, 1798
5—City Assembly Rooms~Library
6—Sat. Morning Visitor Office
7—Edw. J. Coale's Bookstore; A Poe Haunt
8—Mechanical Fire Engine Co.,
 33 So. Calvert St., 1849

9— Seven Stars Tavern
10—Matthew Bleakley's Armisted Hotel
11—Widow Meagher's Oyster Place, 1849
12—Bradshaw's Hotel
13—Phila. & Wilmington R.R. Station
14—Egyptian Hall of Poe's Lecture
 ~January 1844
15—Nielson Poe's Law Office

This Poe-themed map of Baltimore from Mary E. Phillips's biography *Edgar Allan Poe: The Man* is helpful in understanding the city as Poe knew it. The map, however, has some mistakes. No. 6 should read "*Saturday Visiter*"; Bradshaw's Hotel, marked as no. 12, was actually the United States Hotel; and no. 13 should read "Baltimore & Ohio Railroad Depot." (Edgar Allan Poe Society.)

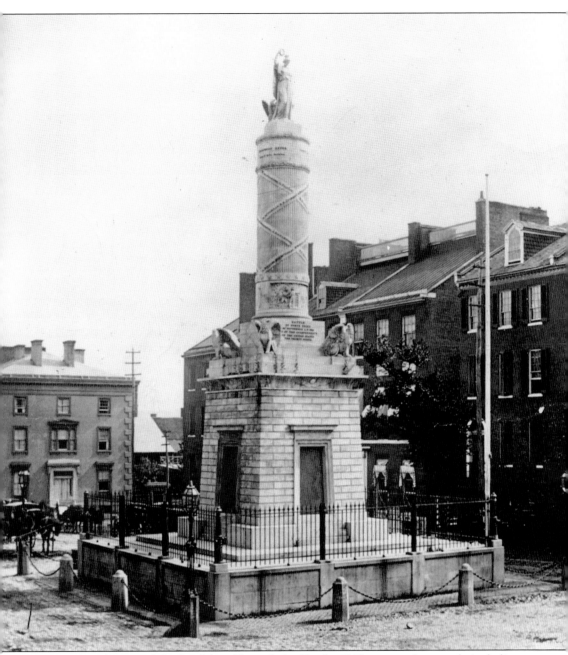

Poe's patron and mentor, John Pendelton Kennedy, had by the 1840s written four novels, including his best work, *Horse-Shoe Robinson*. An early believer in Samuel Morse's telegraph, he had been instrumental in securing government funding for the technology. In 1846, when this daguerreotype of Monument Square was produced, Kennedy was still living in William Wirt's house on the square and writing Wirt's biography. (Library of Congress.)

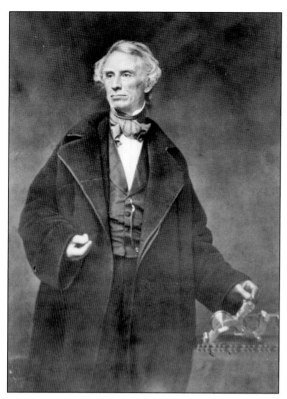

In May 1844, Samuel Morse sent his first long-distance telegraphic message from Washington, DC, to the original Pratt Street railroad depot in Baltimore, one block west of Light Street (not Mount Clare). A device similar to the one shown here was installed in the Baltimore station. The well-known, contrived message "What hath God wrought?" was answered by a real one from Baltimore, "What is the news from Washington?" The Democratic National Convention was then meeting in town, and the technology was put to immediate use. (Both, author.)

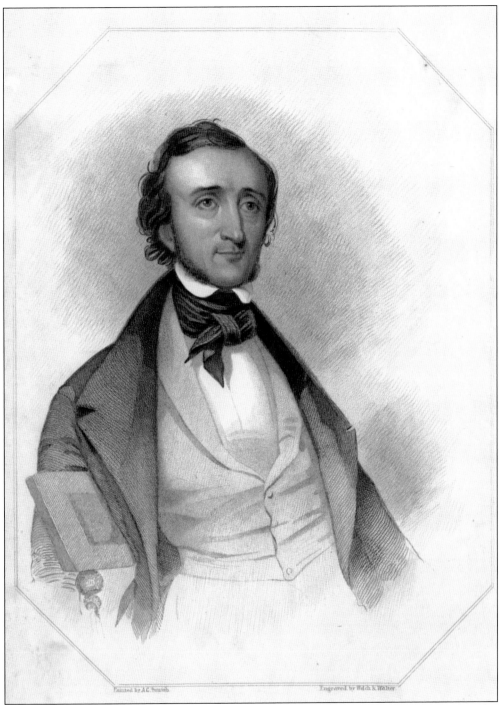

This engraving of Poe by Thomas Welch and Adam Walter was from an original watercolor made by A.C. Smith when Poe was around 35 years old. It was produced in 1844 for *Graham's Magazine*. It appears that Poe liked the engraving more. Remarking about the painting to James Russell Lowell, Poe said, "It hardly resembles me at all." (Author.)

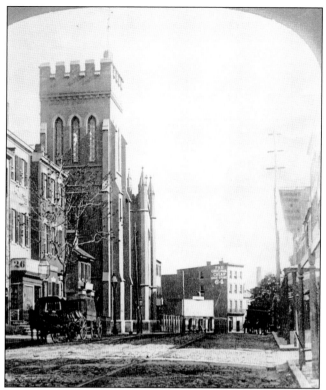

The Independent Order of Odd Fellows was a fraternal organization that established its first American "lodge" in Baltimore. By 1831, it had long quit the Seven Stars Tavern and moved into this palatial structure on Gay Street. In January 1844, Poe lectured here on American poetry, in which he was "witheringly severe" on Rufus Griswold. It is believed he stayed with his cousins the Herrings, while in town. (Author.)

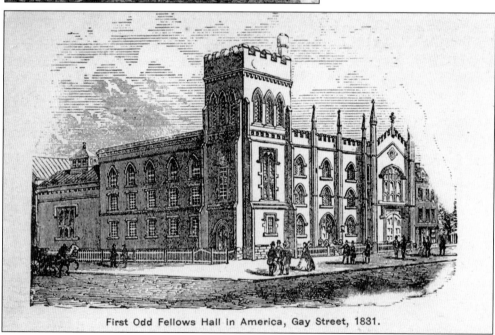

First Odd Fellows Hall in America, Gay Street, 1831.

In May 1844, the Odd Fellows Hall in Baltimore hosted the Democratic National Convention, where the dark horse James K. Polk was nominated for president. Although it housed the largest meeting hall in Baltimore, the building had poor acoustics, and the spectators' gallery was inadequate, contributing to much confusion, which worked in favor of Polk's delegation. (Author.)

Believed to be the earliest photographic image of Edgar Allan Poe, this long-overlooked daguerreotype was made around 1842. The location and studio are unidentified. With muttonchop sideburns and no mustache (he wore no mustache until 1845), this is not Poe's customary appearance. No known photographs were taken of Poe while he was in Baltimore. (Author.)

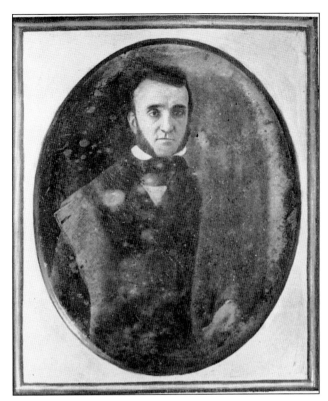

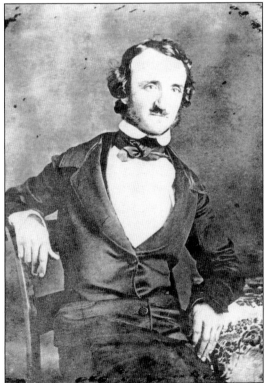

At the request of Mary Elizabeth Bronson, this daguerreotype of Edgar Allan Poe was made in June 1847 at a studio in New York. Poe appears in good health and recovered from his wife's death a few months earlier. Mary's father, an elocutionist, asked Poe to write a poem that he could use in this lectures; the result was Poe's voice of lament, the beautiful "Ulalume." (Author.)

"Deep in earth my love is lying and I must weep alone" is a brief poem attributed to Edgar Allan Poe. Poe's wife, Virginia, was 24 when she died of tuberculosis in 1847 while they were living in New York. This painting of her is believed to have been made immediately following her death. It was then not uncommon to make postmortem portraits, especially if none had been made of the individual while alive. (Enoch Pratt Free Library.)

This portrait of Mary Louise Shew was made in 1838. Without any recompense, she traveled up to the cottage in Fordham from Manhattan, sometimes daily, to nurse the dying Virginia Poe and then her husband, Edgar, who became desperately ill after his wife's passing. Shew is believed to have painted Virginia's death portrait. In gratitude, Poe wrote several poems to her, the publication of which she suppressed. (Poe Baltimore.)

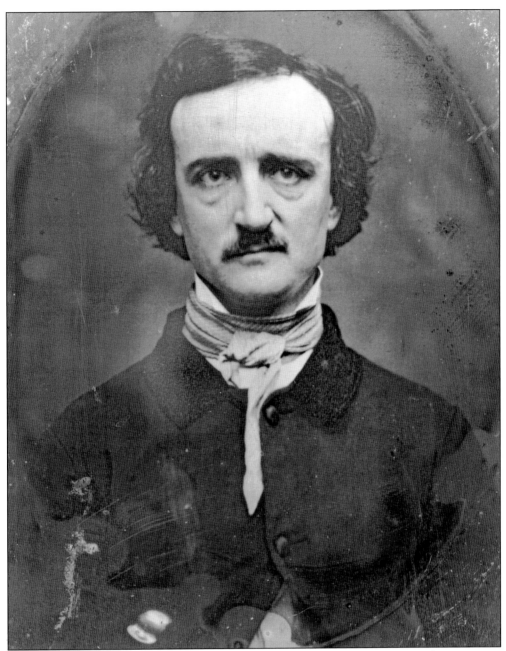

Edgar Allan Poe's fiancée, Sarah Helen Whitman, later named this now iconic daguerreotype of him *Ultima Thule* (pronounced "oolteema tewly"), Latin for "great journey." She was inspired by lines in his poem "Dream-Land": "I have reached these lands but newly, from an ultimate dim thule." The photographic image was made in November 1848 while Poe was in Providence, Rhode Island, only four days after a possible suicide attempt. The endeavor involved swallowing an overdose of laudanum. The attempt failed when Poe's stomach rejected the concoction. This is the only record of Poe ever using opium. (Library of Congress.)

Sarah Helen Whitman, a poetess from Providence, Rhode Island, was in love with Poe long before they met. After his recovery from the death of his wife, he spent much time among friends, who introduced him to the widowed Whitman. Although slightly older, she was cultured, physically attractive, and financially independent. Their engagement was announced, to the chagrin of many, who worked successfully to break it up. (Providence Athenaeum.)

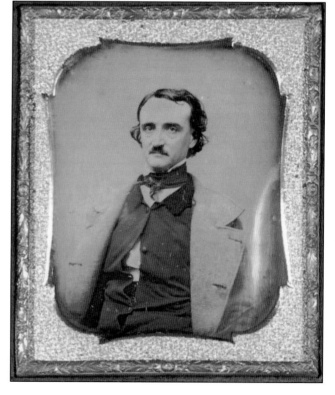

This daguerreotype should be considered a do-over of the *Ultima Thule* image. It was made by the same Providence, Rhode Island, daguerreotypist only days later, apparently at the request of Sarah Helen Whitman, who did not like the first portrait. Poe considered it "the best likeness he ever had," according to Whitman, who was not happy with either image. (Brown University Archives.)

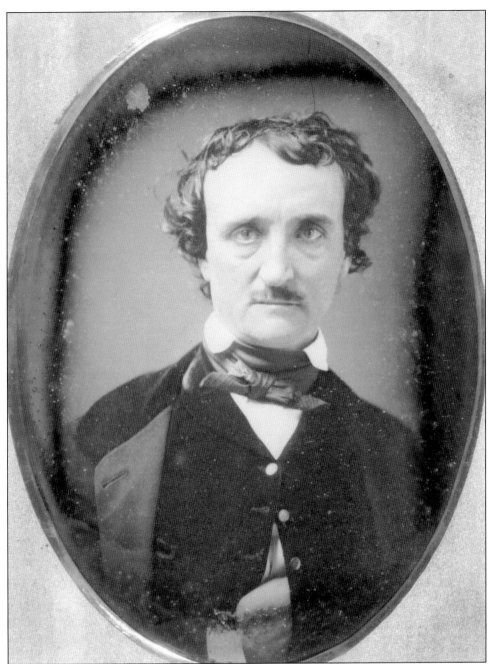

"It does not do him justice—indeed, I have never seen a picture that did." This is how "Annie" L. Richmond described to Poe's British biographer, John Ingram, this daguerreotype that she had made while he was visiting her in Lowell, Massachusetts, during the fall of 1848 or summer of 1849. Of the eight surviving photographic images of Poe, this one has the most clarity and is probably the best representation, despite Richmond's disapproval. Throughout his life, Poe seemed most comfortable with women who were unavailable—wives, mothers, and adolescents. Annie Richmond was married. From letters that have survived, Poe appears to have been deeply, if not platonically, in love with her. (J. Paul Getty Museum.)

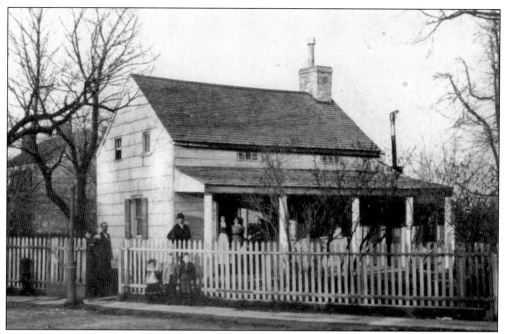

In an effort to aid Virginia's respiratory condition, Poe moved to this cottage in the country north of New York City, in what is now the Bronx. After she died there in 1847, Poe spent much time away from it visiting friends. The house has been moved twice to avoid demolition and is shown here in its second location. Today, it survives as a museum. (Author.)

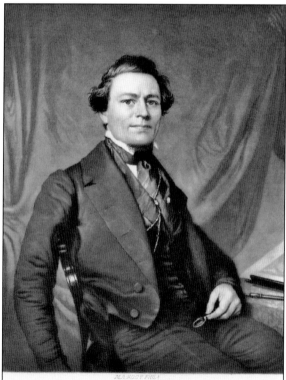

On his way south to Richmond, it is believed that, stopping in Philadelphia, Poe suffered a breakdown following a bout of inebriety. John Sartain (pictured) claims Poe came into his Sansom Street office declaring that he was being pursued by would-be assassins. However, some have questioned Sartain's chronology. (National Portrait Gallery, Smithsonian Institution.)

Five

SEPULCHRE BY THE SEA
1849

The poverty of solid facts explaining Poe's death has made it one of the most enduring mysteries in American literature. In 1849, there was still much guesswork in the practice of medicine. Autopsies were an oddity for which there were no protocols and often performed by someone with little experience. In any event, those treating Poe at Baltimore City and Marine Hospital were certain that his malady was alcohol-related. After his death, these people would have seen no need for a postmortem examination. Poe's cause of death is listed in the *Baltimore Clipper* as "congestion of the brain," a catchall phrase often used as much as a euphemism as a diagnosis. An official death certificate, if ever filed, has not survived.

Here is what is known for sure: Sometime between September 27 and October 2, 1849, Poe left Richmond, Virginia, and arrived in Baltimore on his way to New York. During the day of October 3, he was found in front of the Fourth Ward Hotel at 44 East Lombard Street. At the time of his discovery, he was wearing discarded clothing that was not his, and he was in a state of insensibility, unable to relate what had befallen him. With the help of Joseph Snodgrass and Henry Herring, he was taken or sent to the hospital on Broadway and admitted. He died there four days later. That is it. All the rest is conjecture or of deliberate manufacture. The length of time or his whereabouts in the city before discovery, any abortive travel beyond Baltimore, or any words Poe may have spoken while in the hospital remain unsubstantiated.

Today, there are at least 28 competing theories on the cause of his death, ranging from the obvious to the absurd. The most widely circulated is one in which Poe was kidnapped, stupefied with liquor, and used as a repeat voter during the city election that was being held on October 3. However, like all the other scenarios, there exists no confirmation or creditable witness to it, the theory not being floated until almost 10 years after Poe's death. The real cause may never be uncovered.

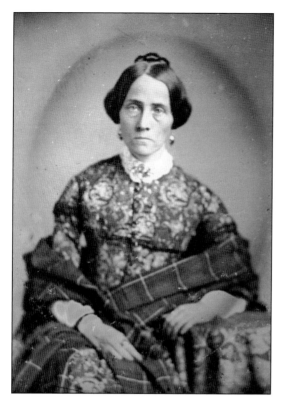

When Edgar Allan Poe left Richmond at the end of September 1849, he was telling everyone that he was engaged to his teenage sweetheart, Elmira (Royster) Shelton, shown here at a later date. Shelton seemed reluctant to set a date; after Poe's death, she denied even agreeing to his proposal, although a letter she penned to Maria Clemm before he left Richmond contradicts this. (Edgar Allan Poe Museum.)

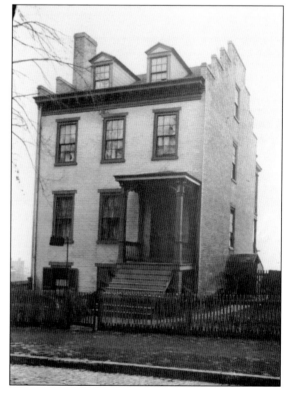

The date of Poe's departure from Richmond is largely pegged to the testimony of his fiancée Elmira Shelton, who stated that when visiting her on September 26 at her house (pictured), he informed her that he was taking the boat for Baltimore the following morning. When Shelton could not find him the next day, she assumed that he had already left town. (Johns Hopkins University.)

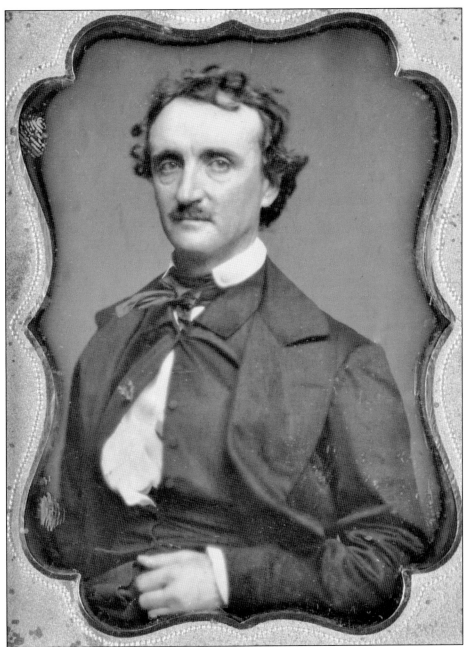

This is the last known photographic image of Edgar Allan Poe, taken in Richmond, Virginia, two or three weeks before his death. Poe had been welcomed as the conquering hero in Richmond. After lucrative lectures, acclaim in the papers, and an engagement to Elmira Shelton, it appeared his luck had finally turned. It is believed that Poe intended to resettle in Richmond and that the trip north was only to collect his belongings and Maria Clemm. He had also accepted an assignment to edit a volume of poems by Marguerite Loud in Philadelphia and had intended to stop there on the way. From all this, it would appear that Poe had every reason to live. Yet he is shown here disheveled, with unkempt hair and physically used up. (Columbia University Rare Book and Manuscript Library.)

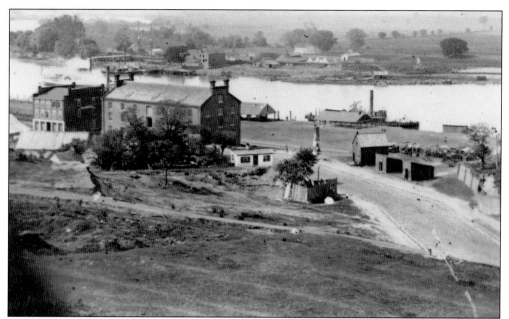

Elmira Shelton stated that Poe had planned to reach Baltimore by steam packet. This method would have taken him to Norfolk, Virginia, on the Powhatan Line, where he would transfer to a boat operated by the Baltimore Steam Packet Company. By this time, these passenger steamers had saloons, the concession usually owned by the ship's captain. Shown here is Rockett's Landing, the point of departure from Richmond. (Library of Congress.)

When Edgar Allan Poe's steamer reached the approaches to Baltimore harbor, Fort Carroll was still being built under the supervision of Robert E. Lee. Today, the island fortress lies derelict. This is the view Poe would have had when his boat passed by in the fall of 1849. (*Baltimore Sun.*)

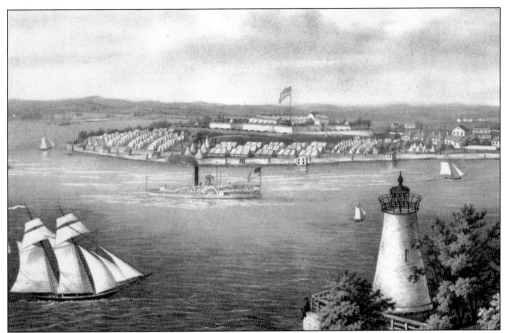

All watercraft entering the city of Baltimore navigate this passage between Fort McHenry and Lazaretto Point. In this rendition made during the Civil War, the distance appears narrower than it actually is, due to the exaggerated representation of the lighthouse. Note the farms and undeveloped area to the right of the fort in what is today the community of Locust Point. (Enoch Pratt Free Library.)

This is believed to be the earliest known daguerreotype of Baltimore's Inner Harbor, taken around 1845. This southern view shows the crags of Federal Hill, created by years of mining it for fill dirt. The signal or observation tower is still in place, and ships are moored at its base, where Key Highway is today. Poe's boat would have landed on the northern shore at Spear's Wharf. (Author.)

Poe would have disembarked at Spear's Wharf, shown behind the steamer *Herald* in this 1849 daguerreotype. The domed structure in the back is the Exchange Building. If taking a train to Philadelphia, Poe would have had to walk about eight blocks to the station at President Street, where a new, larger depot was being constructed next door. (Maryland Historical Society.)

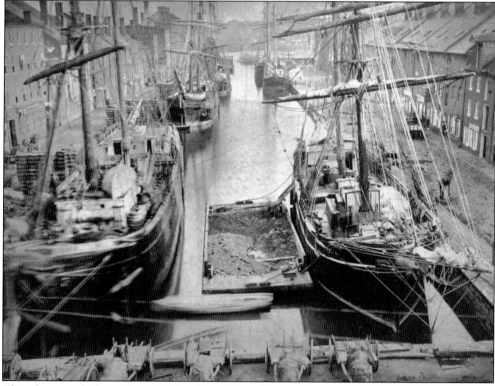

This photograph shows Spear's Wharf from Pratt Street. The warehouses stretching to the end of the piers were obliterated in the great fire of 1904. In this image, no humans appear. With not a living soul in sight, it must be Sunday morning! (Maryland Historical Society.)

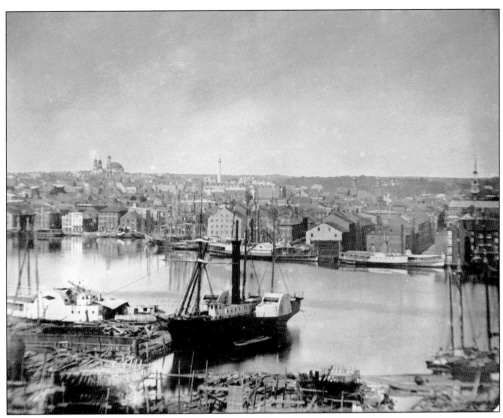

The view in this 1849 daguerreotype of the Inner Harbor looks northwest from the east side of Federal Hill. The steamers *Philadelphia* and *Osiris* are moored to the end of the wharves off Pratt Street, while a good view is afforded of an unidentified side-wheeler. The cathedral and Washington Monument are clearly visible in the background, with not a utility pole to be found anywhere. (Maryland Historical Society.)

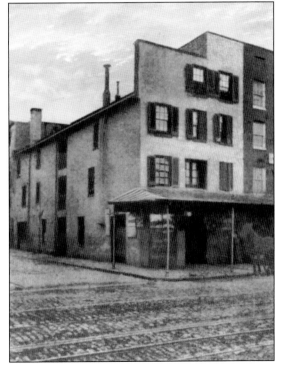

The establishment seen here is reputed to be the Widow Meagher's oyster bar. In 1889, an unidentified man told biographer Eugene Didier that he indulged with Poe here the night before Poe was discovered on Lombard Street. However, a search in period directories revealed no one doing business under the name "Widow Meagher," "Meagher," or any spelling variation of that name. (Johns Hopkins University.)

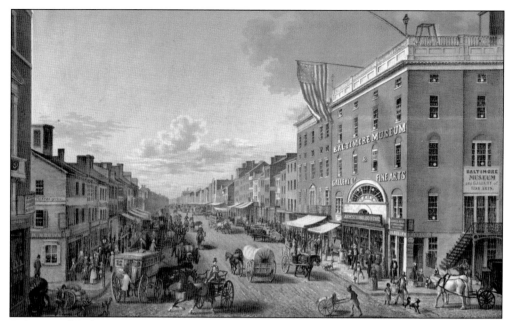

Calvert and Baltimore Streets, as depicted here in 1850 by E. Sachse, has always been a busy crossing. The Baltimore Museum on the northwest corner opened in 1829. In Poe's time, it was both a natural history museum and a performing arts theater. In yet another unsubstantiated account of Poe's last days, he was seen lying beneath the steps to the second floor of the museum. (Enoch Pratt Free Library.)

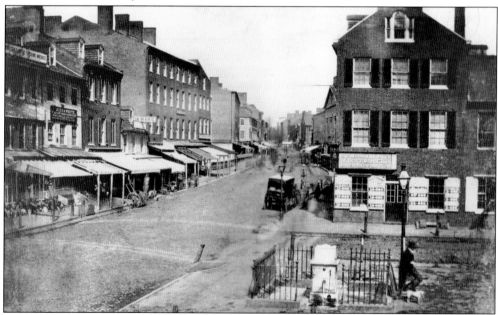

This well-known image shows Harrison and East Baltimore Streets around 1850. The view looks east into Old Town. The bridge over the Jones Falls can be seen just beyond the wagon parked at the curb. The water fountain and McDonald's lottery office on the right are where the Brokerage Building stands today. Poe was found just a few blocks south, on the other side of the Jones Falls. (*Baltimore Sun.*)

In 1849, passengers heading to Philadelphia and New York from Baltimore boarded a train on President Street. The Pennsylvania, Wilmington & Baltimore Railroad was then using a smaller building to process travelers. The grand station shown was under construction when Poe had stopped in the city; it would be completed during the following year. (Library of Congress.)

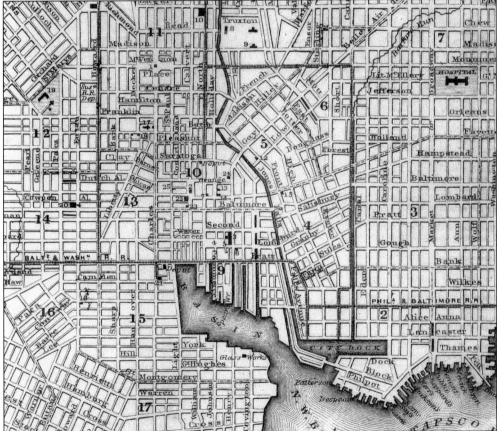

A magnifying glass may be required to appreciate this 1849 street map of Baltimore, which identifies the main rail lines and train depots as well as many points of interest. The larger numbers indicate political districts or wards. The Fourth Ward Hotel, where Poe was found, would have been located around where the number 4 can be seen. The hospital depicted on the right, in the spot where Johns Hopkins is today, was a state-run facility for psychiatric patients. Not shown, just a few blocks south, is the hospital where Poe died in October 1849. (Author.)

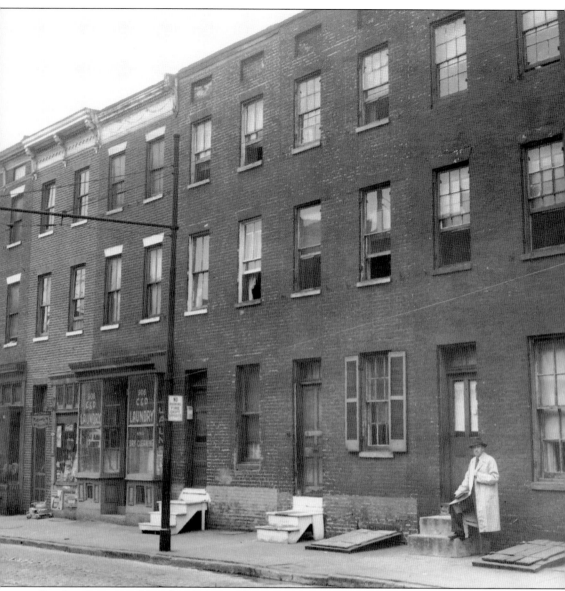

On the afternoon of October 3, 1849, Edgar Allan Poe was discovered sitting (or lying) in front of the Fourth Ward Hotel at 44 East Lombard Street. The man who recognized Poe also saw the seriousness of his condition and summoned help. By the time his friend Joseph Snodgrass came, Poe had been moved indoors, and arrangements were being made for a room upstairs. His relative Henry Herring arrived soon after, when it was decided that Poe should go to a hospital and a hackney coach was ordered. All this transpired to the curiosity of those in Gunner's Hall, the tavern inside the hotel. This October 1949 photograph shows Richard Hart, then vice president of the Edgar Allan Poe Society, at the same location, now 912 East Lombard. These buildings were not standing in 1849, but constructed later. Today, these, too, have been replaced by residential town houses. (*Baltimore Sun.*)

This photograph shows Richard Hart on October 3, 1949, pointing to the approximate spot of Poe's discovery on East Lombard Street. When found, Poe was in clothing that had been retrieved from the trash. He was in a state of stupefaction, unable to communicate what had happened to him or when he actually arrived in Baltimore. The cat shown behind Hart has both eyes! (*Baltimore Sun.*)

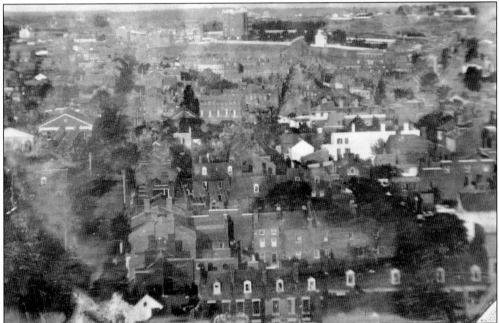

The view in this 1849 daguerreotype looks east from the top of the Shot Tower on Fayette Street. Careful examination reveals gas lamps atop the poles lining Fayette Street. The tall structure at the top is the hospital to which Poe was taken, or sent. Just behind it are the Fairmount Building and five-acre park. Beyond Broadway, there appears to be little development. (Maryland Historical Society.)

tern or design, jy4 co6fr
All of which are offered at the lowest market rates

BALTIMORE CITY AND MARINE HOSPI-
TAL, BROADWAY.—The Medical Profession
and the public are respectfully informed that this es-
tablishment, formerly known as the Washington Col-
lege Hospital, has been reorganized and undergone a
complete renovation in every comfort and conveni-
ence, and now presents one of the best retreats for
the sick and invalid. The increase of the population
and commerce of the city demand such an institu-
tion, and we trust that this retreat, conducted as it
will be on the most liberal plan, will meet with the
approbation and support of the community.
 Professional gentlemen, well known for their ta
lent and experience as Surgeons and Physicians, will
have charge of the sick, and every effort will be made
by the undersigned, whose family resides in the house,
that may contribute to the comfort and relief of those
who may become inmates of the institution. Any fur-
ther information may be obtained by addressing
 JOHN J. MORAN, M. D.,
j 4-1aw2w* Resident Physician.

CHOLERA PREVENTATIVE AND CURE—
THE ASIATIC GOLDEN LIFE DROPS, (an
East India preparation,) is a certain and never failing
preventative for the Cholera; it is also a positive cure

As early as July 4, 1849, the name of the hospital to which Poe was taken had been changed to Baltimore City and Marine Hospital, which accurately reflected the facility's clientele. In this classified advertisement in the *Baltimore Sun* that day, the administrator of the new concern, Dr. John Moran, is already demonstrating his fondness for embellishment. (Enoch Pratt Free Library.)

After his discovery on Lombard Street, Poe was taken to this hospital on Broadway, east of the city, where he died on the morning of October 7, 1849. Tradition holds that he had been in a private room on the second floor. However, a new account disputes the location and level of care Poe received. By 1857, the hospital had become the Church Home and Infirmary. (*Baltimore Sun.*)

In 1865, this monument, at 100 North Broadway, was dedicated to Thomas Wildey, who founded the first American branch of the Independent Order of Odd Fellows, in Baltimore. Shown behind is the hospital building in which Poe perished. Six years later, in 1871, Maria Clemm, having been a resident for many years prior, also died in this same building. (Library of Congress.)

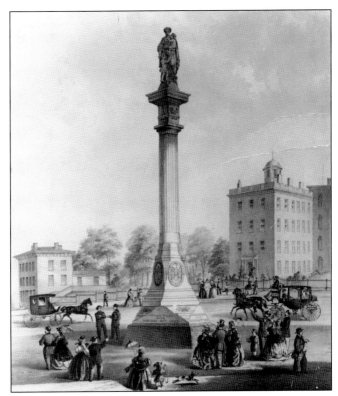

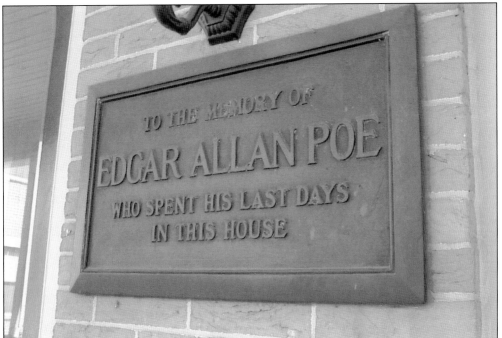

This bronze plaque was donated in 1909 by Mrs. Thomas Cullen and placed in the rotunda of the Church Home and Hospital. It was later relocated to the outside wall of the front porch. Today, it can be viewed without entering the building, which is closed to the public. (Author's photograph.)

There is some uncertainty concerning the exact location of Poe's hospital room. Traditionally, it was on the second floor in the tower west of the front entrance, where a stairway now exists. However, a longtime caretaker asserted that the stairway was part of the original design. A related claim is that Dr. Moran confused Poe's room with one from the other side of the building. (*Baltimore Sun*.)

Church Home and
Infirmary,
Wildey Monument,
Baltimore, Md.

This northern view at the top of Broadway shows the Thomas Wildey Monument and Church Home and Infirmary around 1900. By then, a bank of balconies was hung on the eastern end of Poe's hospital, one of many subsequent modifications. The building escaped demolition in 2000 and survives today as a private apartment complex. (Author.)

HERE, BEFORE ALTERATION OF THIS
BUILDING, WAS THE ROOM IN WHICH
EDGAR ALLAN POE
DIED, OCTOBER 7, 1849

Even if Poe was unaccompanied when he arrived at the hospital, it is likely the staff there would have been given the identity of the patient from the hack driver and assigned him a private room. In 1938, the Edgar Allan Poe Society arranged to have a bronze plaque, pictured above, made to mark the accepted location of Poe's room, then a stairway in the Church Home and Hospital. The cost of the marker was paid by an anonymous donor from Baltimore. The below photograph shows Dr. N. Bryllion Fagin, author of *The Histrionic Mr. Poe*, posing with the marker in October 1949 during the weeklong centennial of Poe's death. (Both, *Baltimore Sun.*)

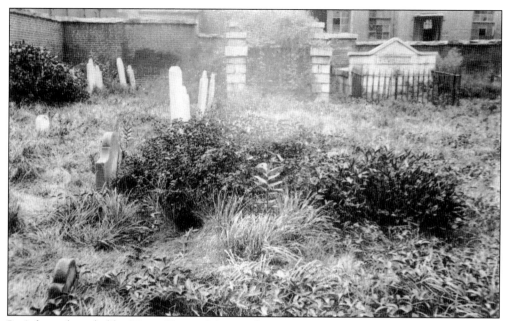

Poe's funeral was held at Henry Herring's house, then on Pratt Street. Following this, his remains, along with a small cortege, traveled to the Westminster Presbyterian Cemetery in the western precincts. After a short Methodist-Episcopal ritual conducted by the Reverend W.T.D. Clemm, a relative of Poe's wife, he was interred in the family lot beside his grandfather, David Poe Sr. Shown here around 1890, the graves were still without any markers. (Johns Hopkins University.)

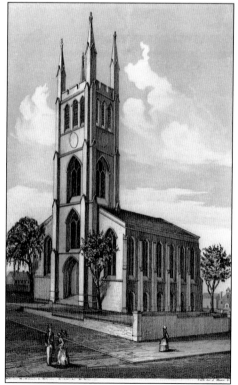

In October 1849, the Westminster Presbyterian Church had not yet been built; Poe's interment was conducted in an open yard. Construction of the church, completed in 1852, took place over the existing graves at the north end of the cemetery. Happily, the Poe family lot was not among them. (Maryland Historical Society.)

Six

PENNIES FOR POE
BALTIMORE VENERATES ITS SON

Edgar Allan Poe was hastily buried on October 8, the day following his death. Because the notice did not appear in the paper until that day, the number of those attending the burial was small, no more than eight people. His death took many by surprise, no one more than Maria Clemm. "Eddy" had been her steadfast companion and her primary source of income. Claiming to have instructions from her nephew and acting as executor, she apparently approached Rufus Griswold in New York to produce a collection of Poe's works, with her as the beneficiary. Griswold had shared a long-standing animosity with Poe, the depth of which Clemm may not have been aware. Although he made a competent effort with Poe's collection, Griswold wasted no time in worsening Poe's personal reputation in an attending, libelous memoir. Much of what is believed today about Poe came from Griswold's vindictive pen.

In 1850, the year after Poe's death, Baltimore was the second-largest city in the United States. Its number of 170,000 citizens was greater than either Boston or Philadelphia. Politically, even the manufactured town of Washington, DC, stood in its shadow, with the veritable monopoly Baltimore held on party conventions before the Civil War. But its economic impact was greater. The railroad gamble was paying off and had given the city a head start on the other growing towns. The level of trade Baltimore enjoyed with South America, the Caribbean region, and the prosperous Southern states was promising to make her an equal of New York. Then came the Civil War and its aftermath. The city had been spared the holocausts of Richmond and Atlanta, but, unlike the wartime boom enjoyed in the Northern cities, Baltimore's blockaded economy sank. Although trade with South America resumed after the war, the local and Southern markets vanished. Even the benefits from the railroad seemed to be a "one-off," eventually slowing as rail systems from other regions expanded. Before finding her stride again in the late 19th century, Baltimore had been eclipsed by several cities in the North.

This nighttime view of the Baltimore Museum and Barnum's City Hotel on Calvert Street depicts a Battle Monument of fantastic proportion. The neighborhood around *Lady Baltimore* was still a fashionable place to live, but, by the 1850s, many well-to-do Baltimoreans had addresses close to the Washington Monument, including John Pendleton Kennedy, who built a mansion on Madison Street just one block off the square. (Enoch Pratt Free Library.)

Baltimore's gamble in steam-powered railroads paid off, and the city became rail-centric. By 1850, four separate train depots were operating and undergoing improvement. That year, the President and Calvert Street Stations opened, the latter at Franklin and Calvert Streets, in the area of the Baltimore Sun Building today. It served as the terminus for the Baltimore & Susquehanna Railroad, which connected to York and Columbia, Pennsylvania. (Library of Congress.)

Although not in use while Poe was alive, the plans for and construction of Baltimore & Ohio Railroad's Camden Street Station commenced soon after his death. With train traffic approaching from the south and its location two blocks below Pratt Street, steam locomotives could pull right up to the building without violating the "no-locomotives-in-town" ordinance. This photograph was taken after the Civil War. (Library of Congress.)

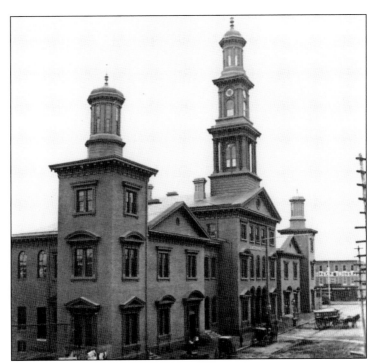

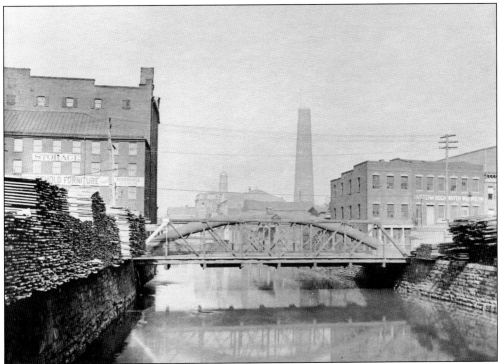

Shown here is the Lombard Street Bridge over the Jones Falls in the late 19th century. The Fayette Street Shot Tower in the background provides a point of comparison to the contemporary location. Henry Herring, husband to Poe's Aunt Elizabeth, kept a yard in the so-called lumber district (pictured). (Maryland Historical Society.)

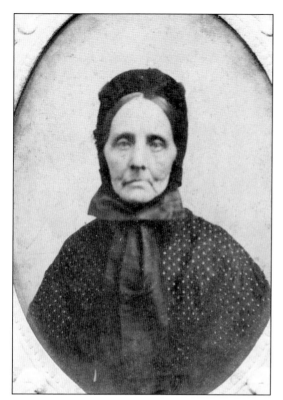

When Poe's mother died in 1811, his younger sister Rosalie was taken in soon after by the Richmond family of William Mackenzie. Rosalie had a comfortable home, but she was never formally adopted. After the Civil War destroyed the Mackenzies' fortune, Rosalie was left to subsist on her own, reduced to street-peddling relics and images of her famous brother. She died in 1874 at age 68. (Edgar Allan Poe Museum.)

When working for *Graham's* magazine in Philadelphia, Poe, hat in hand, asked everyone for contributions, including Henry Wadsworth Longfellow (pictured). Later in 1845, while with the *Evening Mirror* and *Broadway Journal*, Poe would accuse other writers of plagiarism, including Longfellow—not word-for-word theft but, rather, borrowing too much from Tennyson. Yet, after all the abuse to which Poe subjected him, Henry Longfellow still assisted Maria Clemm in her closing years. (Author.)

This is the only known image of Dr. John J. Moran, the administrator of Baltimore City and Marine Hospital, in October 1849. Much of the persistent misinformation about Poe's final days in Baltimore can be traced to Moran. Dr. Moran's many and varied descriptions of Poe's last moments are as murky as this photograph of him. (Mary Riley Styles Public Library.)

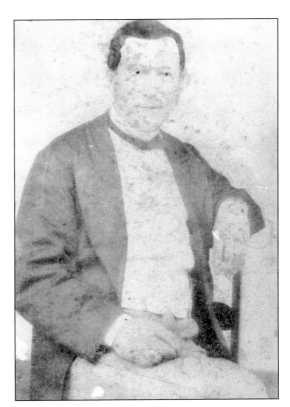

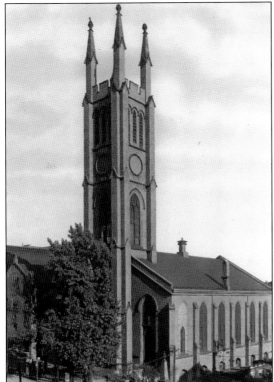

The Westminster Presbyterian Church was built in 1852, three years after Poe's burial, in an effort to protect the cemetery, which was under the jurisdiction of the First Presbyterians. Although Poe's grave was not beneath the church, it remained for a time unmarked, and the yard eventually fell into neglect (see page 90). Many coming to view his burial site were appalled. (Author.)

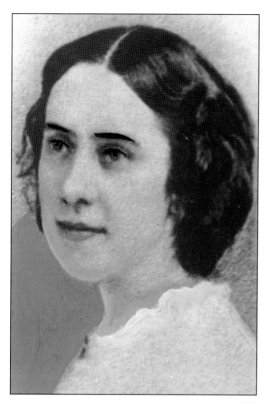

One of those dismayed at the state of Poe's grave at the Westminster Cemetery was Sara Sigourney Rice, a Baltimore schoolteacher who, in 1865, began a fundraising effort for a suitable memorial to mark his burial site. She helped to create a "Pennies for Poe" campaign among Baltimore's schoolchildren, which generated almost half of the approximately $1,500 the monument and its placement would cost. (Jeffrey Savoye.)

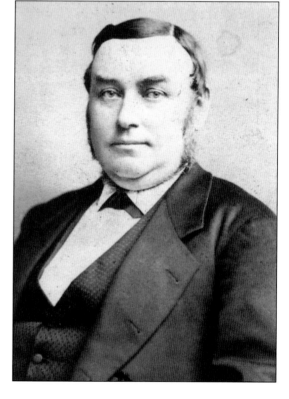

By 1873, when it became known that the amount raised for Edgar Allan Poe's monument was insufficient, George William Childs, a native Baltimorean and successful Philadelphia newspaper publisher, came forward to contribute the balance. Childs was an acquaintance of Poe's during the poet's days in Philadelphia. (Library of Congress.)

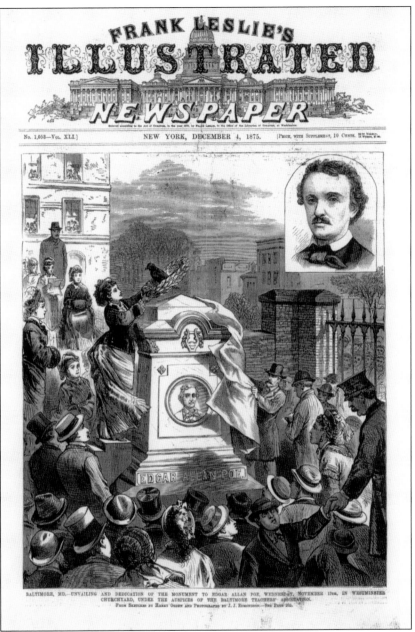

FRANK LESLIE'S
ILLUSTRATED
NEWSPAPER

No. 1,053—Vol. XLI] NEW YORK, DECEMBER 4, 1875. [Price, with Supplement, 10 Cents.

BALTIMORE, MD.—UNVAILING AND DEDICATION OF THE MONUMENT TO EDGAR ALLAN POE, WEDNESDAY, NOVEMBER 17th, IN WESTMINSTER CHURCHYARD, UNDER THE AUSPICES OF THE BALTIMORE TEACHERS' ASSOCIATION.
FROM SKETCHES BY HARRY OGDEN AND PHOTOGRAPHS BY J. J. EDMONSON.—SEE PAGE 252.

The ceremony for the monument's dedication was held on November 17, 1875, and was attended by an estimated 1,000 people. The formal addresses were delivered in the main hall of the Western Female High School, after which the throng repaired to the nearby cemetery for the unveiling ceremony. The woman depicted in this engraving, placing the wreath of flowers and raven-shaped arrangement atop the obelisk, is Sara Sigourney Rice. The first funds for the memorial were raised through her personal efforts; when the project stalled in 1871, she took control. When it was discovered that there was not enough room to accommodate the new monument at Poe's original burial site, it was decided to relocate his remains, along with those of Maria Clemm, to a more prestigious location in the northwest corner of the cemetery. Permission from the descendants of the two individuals already buried there had to be secured. (Jeffrey Savoye.)

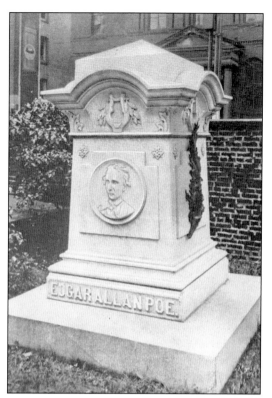

This impressive marble monument, designed by Baltimore City Hall architect George A. Frederick, now stands over the final resting place of Edgar Allan Poe, his wife, Virginia, and his mother-in-law, Maria Clemm. It was created in 1875 and dedicated during a great ceremony that same year. The site, on the corner of Fayette and North Greene Streets, is one of the most photographed and visited in Baltimore. (Author.)

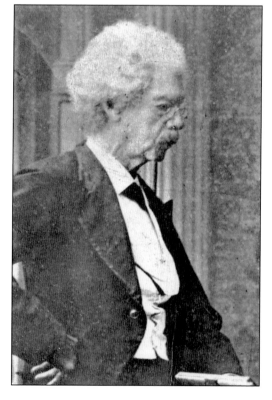

John Hewitt was one of the country's best-known songwriters before the Stephen Foster era. As he grew older, Hewitt came to accept Poe's genius. Hewitt was invited to the ceremonies honoring Poe in 1875, as much for his celebrity as for his association with the poet. (Enoch Pratt Free Library.)

Walt Whitman also attended the dedication of Poe's monument at Baltimore in 1875, but, recovering from a stroke, he did not give an address. The two had met while Poe was editing the *Broadway Journal* and had just published his essay. Whitman was 26 years old at the time. When recalling their meeting, he would say that Poe was "very kindly and human, but subdued, perhaps a little jaded." (Library of Congress.)

Neilson Poe had not yet been appointed judge for the Baltimore orphan's court when asked to speak at the dedication of Poe's monument in 1875. Neilson, a second cousin, had by then become the Poe family spokesperson in Baltimore. He claimed to have purchased an earlier headstone for Poe, which was destroyed when a train crashed into the monument maker's yard. (Enoch Pratt Free Library.)

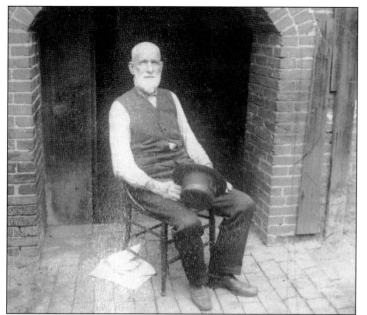

George Spence was the sexton of Westminster Presbyterian Church when Poe was buried there in 1849, and he was still working in that capacity in 1875 when overseeing the exhumation and reburial of Poe's remains. In the intervening years, he and Neilson Poe had been conducting visitors to Poe's original gravesite. Stories of Phillip Mosher Jr. being mistakenly buried under the new monument have no validity. (Johns Hopkins University.)

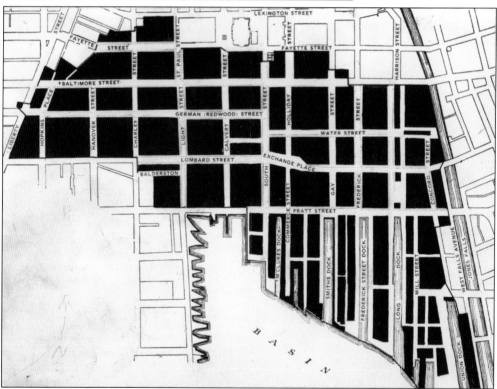

In February 1904, a great fire destroyed Baltimore's downtown business district, including some 1,500 buildings, among them newspaper offices and their photographic archives. Many historic sites and revered structures were obliterated, including the Seven Stars Tavern. This map shows the destruction zone and the protective barrier provided by the Jones Falls. Poe's grave, the house on Amity Street, the Latrobe house, and Church Home Hospital were not damaged. (Author.)

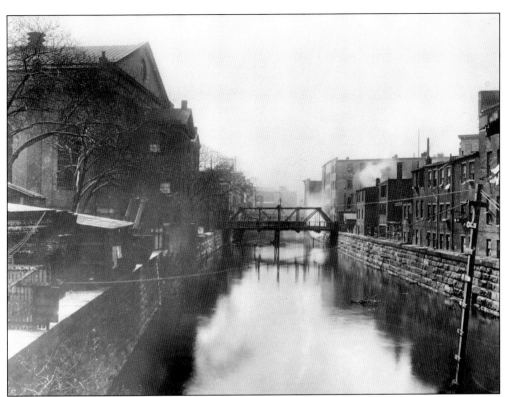

The once free-flowing Jones Falls in Baltimore City had, by the turn of the 20th century, been incarcerated by stone. By 1911, when this photograph was taken, it had long been a conduit for untreated sewage and would soon be covered. Here, Fayette Street crosses just below St. Vincent's Church (left). Today, this is the southern terminus of the Jones Falls Expressway. (Maryland Historical Society.)

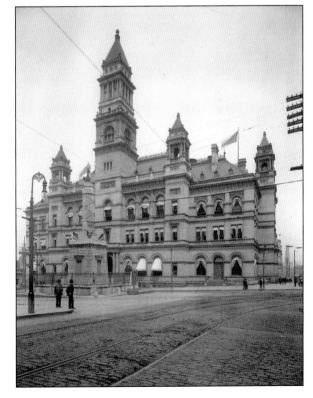

This image illustrates Baltimore's renewed energy at the turn of the 20th century. This grand post office was the third structure to occupy the east side of the battle monument and it, too, would be replaced in 1932, when the current city courthouse was completed. The post office and City Hall (behind it) survived the 1904 fire. (Library of Congress.)

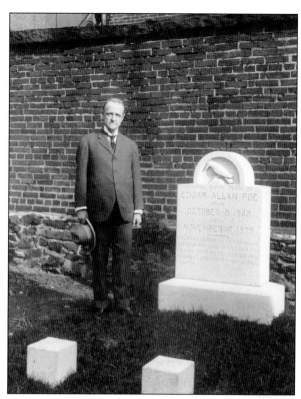

Orrin C. Painter had inherited from his father, William, a reverence and passion for Edgar Allan Poe. William had actually befriended Maria Clemm when she was at Church Home in the 1860s. A regular visitor to the memorial at Westminster Church, Orrin saw the rectitude of marking the original burial site of the poet and provided funding for the cenotaph's creation in 1913. However, not discovered until July 1920, the marker had been mistakenly placed in the lot belonging to S.P. Tustin's grandfather, along the eastern wall of the cemetery (left). Without George Spence (who had died in 1899) for instruction, in-depth research was required to find the correct spot and was undertaken by May Garrettson Evans, Edgar Allan Poe Society president. After another year, she was able to arrange the stone's move to its current location. (Both, author.)

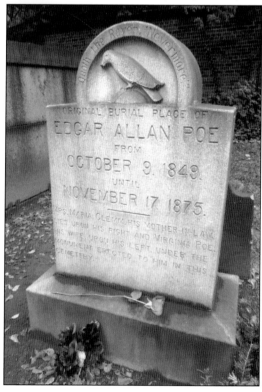

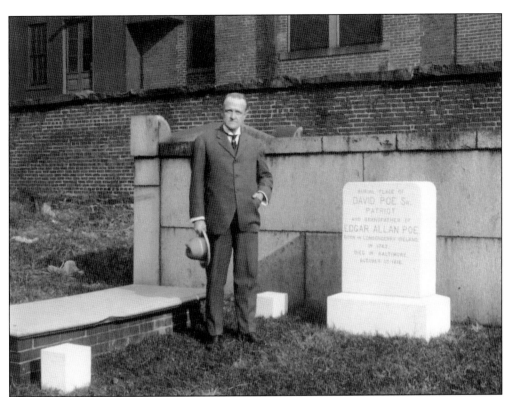

Edgar Allan Poe was originally buried in the Poe family lot, No. 27, along with his elder brother Henry and grandparents Mr. and Mrs. David Poe Sr., of which none were marked with a traditional headstone. When Orrin Painter commissioned the cenotaph for Poe's original gravesite at Westminster Cemetery in 1913, he also funded the creation of this simple marker for his grandfather. To mark the boundaries of the family lot, four cornerstones were created. Unlike with the gravestone for Edgar, no drama resulted from the placement of his grandfather's. (Both, Johns Hopkins University.)

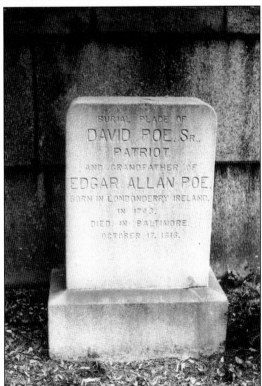

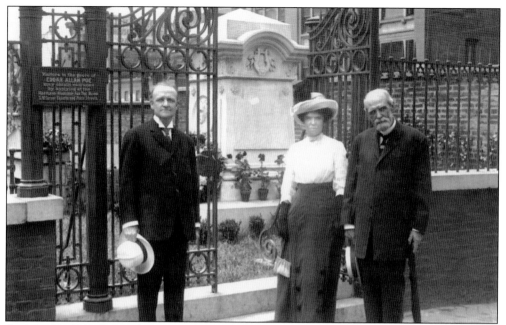

On May 30, 1912, Poe enthusiast and philanthropist Orrin C. Painter stands with Dr. Henry E. Shepherd and his daughter Lillian at the newly built Fayette Street gate to Westminster Presbyterian Cemetery. Painter had also financed its construction. Prior to this, visitors entered the cemetery by the carriage gate on Greene Street. (Johns Hopkins University.)

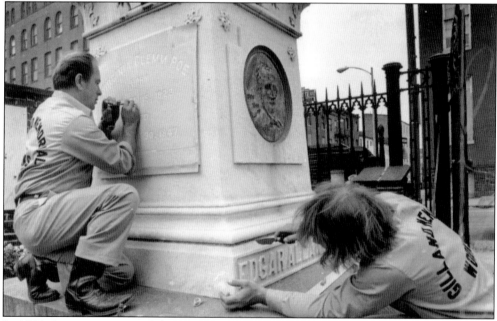

In 1977, the congregation of the Westminster Presbyterian Church disbanded, and the care of the building and cemetery was taken over by the Westminster Preservation Trust. The Poe monument also underwent restoration, with the names of Maria Clemm and Virginia Clemm Poe inscribed onto its flanks (pictured). That same year, actor Vincent Price made a pilgrimage to the monument. (*Baltimore Sun*.)

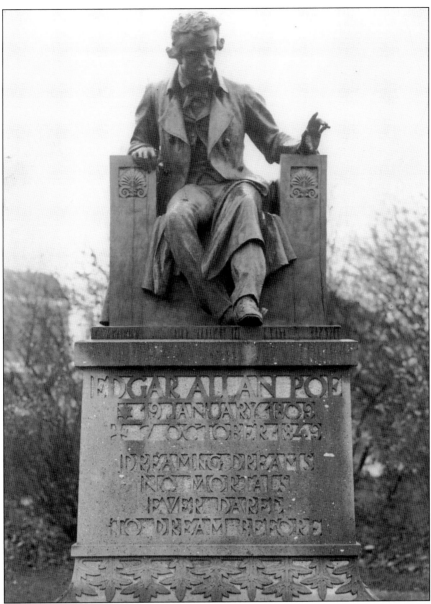

In 1907, the Edgar Allan Poe Memorial Commission was formed to create a suitable monument to the poet for display at a prominent site in the city of Baltimore. However, the project only got off the ground four years later, when Orrin C. Painter pledged half of the projected $10,000 cost. Mrs. John C. Wrenshall, the first president of the commission, contacted Sir Moses Ezekiel, a celebrated sculptor from Virginia who was working in Rome. Wrenshall requested a sitting position for the figure, but otherwise left the design to Ezekiel. After many catastrophic delays that threatened to end the project—including the complete destruction of the first rendition by fire, a world war, and the death of Ezekiel in 1917—the bronze statue was finally sent to the United States. Disagreements over its location caused even more delays, but the statue was unveiled on October 20, 1921, at Wyman Park, with approximately 500 people in attendance. The sculpture appears to show Poe leaving his seat, but according to its creator, the figure leans forward with eyes closed, "listening in rapt attention to a divine melody." (*Baltimore Sun*.)

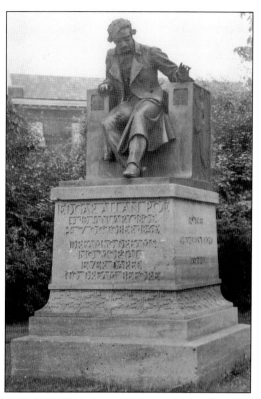

Poe's literate followers were troubled by two mistakes on the original plinth's inscription. Although he could do nothing about the missing *i* from the word *dreaming*, Edmond Fontaine chiseled off the mistakenly added letter *s* in *mortals*, an act for which he was arrested. This image shows the plinth after Fontaine's chiseling. In 1983, the statue was moved to the University of Baltimore's Gordon Plaza at Maryland and Mount Royal Avenues. (*Baltimore Sun.*)

An event reminiscent of Neilson Poe's train-wrecked headstone took place in 1941, when a car crashed into the nearby wall at the Poe monument, knocking down a tablet placed there by the Baltimore Press Club (shown). The plaque, erected in 1925, stated that the Press Club was caring for Poe's gravesite. The club's ardor was short-lived; by 1930, the Edgar Allan Poe Society was performing this duty. (Author.)

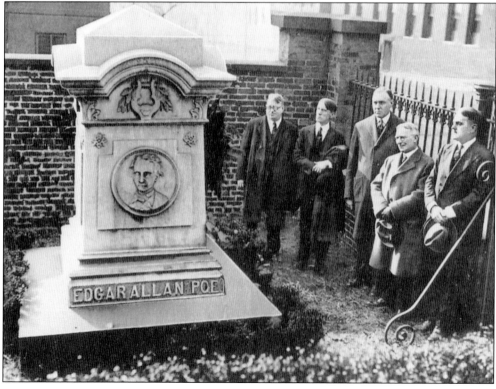

In April 1939, the City of Baltimore purchased the duplex structure at 203 and 205 North Amity Street from Maggie Elizabeth Eichelberger for $650 (in fee). It was also announced by Dr. John C. French that, although the Edgar Allan Poe Society would take charge of the house, the organization had no plans for opening it as a museum after its restoration. (Edgar Allan Poe Museum.)

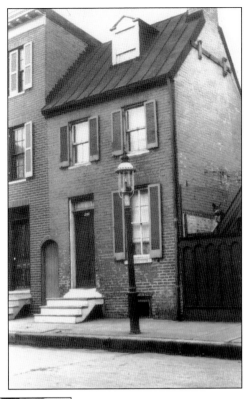

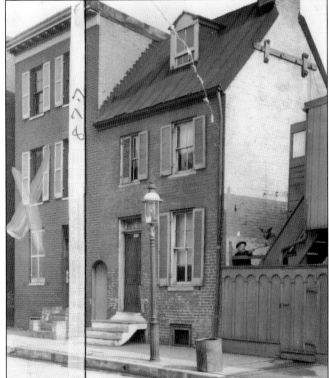

This photograph of the Poe House on North Amity Street was taken in 1939. Behind the *Sun* newspaper's broad crop line, the much-modified northern half of the duplex structure can be seen. The fence and steps to the right are attached to a separate structure, which operated as a paint store fronting on Lexington Street. (*Baltimore Sun.*)

When Edgar Allan Poe lived in this house on North Amity Street (behind the lamppost) from 1833 to 1835, there were only two other structures on the block. The row houses surrounding it in this image were built after the Civil War. It is not clear if the north side of the twin-house was modified to match the style of existing buildings above it, or if the southern half, where Poe lived, remained unaltered because its historical significance was known and appreciated. More families would occupy the house after the Clemm-Poe family moved out. In a 1930 newspaper article, James Knox and his family claim to have been the longest tenants of the house, having lived there since before the turn of the century. Knox also states that Poe's residence at 203 North Amity Street was common knowledge. (Enoch Pratt Free Library.)

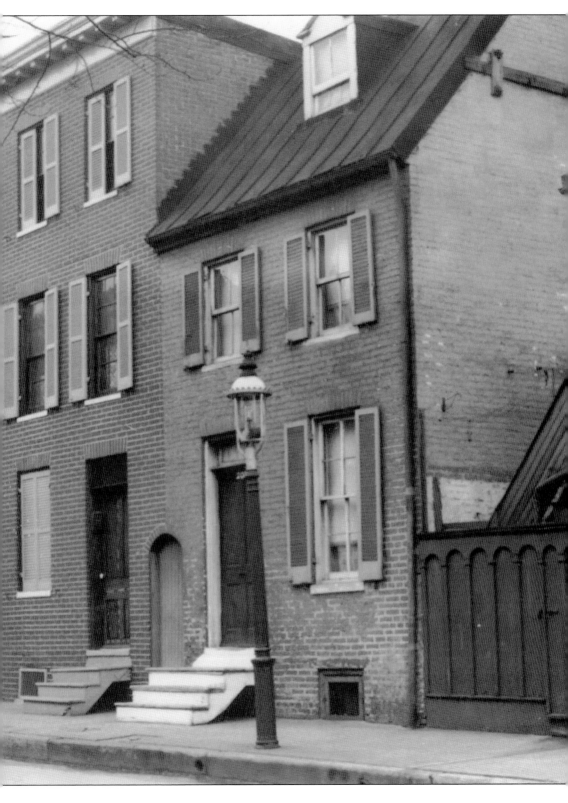

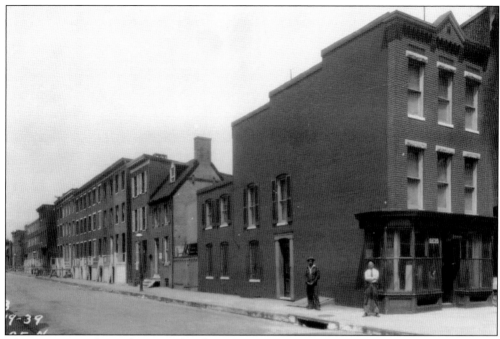

This rare image shows the east side of North Amity Street prior to its demolition for a public housing project. The shack-like Poe house at 203 is sandwiched between a block of vacant row houses and Arthur Vollerthum's paint store that fronted on Lexington Street. The door on the side of Vollerthum's building, an entrance to the residence, was actually 201 North Amity Street. (Johns Hopkins University.)

The sign reads "Edgar Allan Poe Homes," named for the neighborhood's most famous resident. The demolition of buildings began around October 1, 1939 and new owners were moving into completed residences only 12 months later. The 298-home complex included its own central heating plant, community building, and recreation areas. This view is from the corner of Fremont and Lexington Streets. (*Baltimore Sun.*)

110

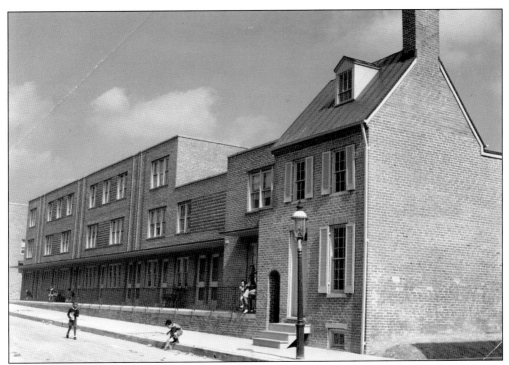

This photograph of the newly restored Poe house on Amity Street was taken on October 10, 1940. The northern half was surgically severed, but the ginnel entrance that originally separated the two lower floors was cleverly retained. On the outside, the house received a new roof, windows, shutters, and front door as well as cleaned and pointed masonry. (*Baltimore Sun.*)

During construction of the Poe Homes housing project, the Poe House was used to qualify applicants. Other uses such as a medical clinic and library branch were also discussed, but the house at 203 North Amity Street stood mostly unused until 1949, when the Edgar Allan Poe Society opened it as a furnished museum. It was unprepared for the public's enthusiasm. (*Baltimore Sun.*)

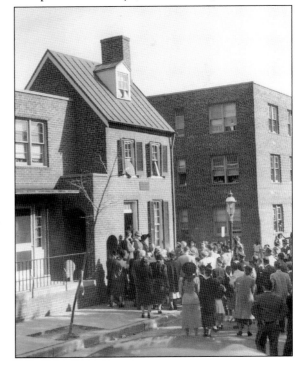

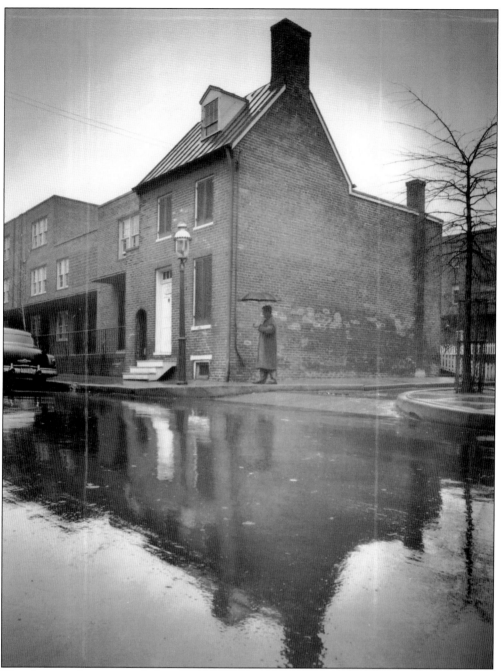

The chimney shown toward the rear of the house enabled the use of a kitchen stove, but it is unclear whether either was in place when the Clemm family resided there. Sometime during the 19th century, a five-foot extension was made to the back of the house. This eventually resulted in a room behind the kitchen, which has not changed in dimension from Poe's time. (*Baltimore Sun*.)

Seven

FOR TOURIST AND PILGRIM
POE'S BALTIMORE TODAY

As might be expected in a city that has become identified with Edgar Allan Poe, it is difficult to travel any distance in Baltimore without encountering a site that is related to the great poet. For example, entering the city from the east on Fayette Street brings one to Broadway. Here, looking left, one will see the hospital building where Poe spent his last hours; there is a historical marker outside to identify it. Continuing down the hill, one passes directly by the Baltimore Shot Tower, in the shadow of which Poe walked daily. Farther on Fayette Street, on the right at the intersection with Calvert Street, is the 1814 Battle Monument, once the "high-rent" district and home of John Pendleton Kennedy, Poe's mentor and benefactor, whom he visited often. Continuing west on this same road, at the corner of Greene Street, is Westminster Hall and the site of Poe's burial. Continuing another eight blocks, the traveler comes to Amity Street. On the right is the small house in which Poe lived when beginning his professional literary career. Perhaps Fayette Street would be more appropriately named Edgar Allan Road.

Of course, there are more Poe-related sites in Baltimore than can be viewed from Fayette Street. The Mount Vernon district includes the John H.B. Latrobe House, in the back parlor of which Poe was lifted from obscurity in 1833. The last house of John Pendleton Kennedy is not far away, as are the Washington Monument and the Baltimore Basilica, which were everyday sites for the poet. To the south, the original Mount Clare Railroad Station still stands, and the Hollins Street Market remains open for business. And on Russell Street, there is the home of the National Football League's Baltimore Ravens, the mascot appropriated from Poe's most well-known poem. So, why is there no street named for him in Baltimore?

SITE OF POE'S DEATH

THIS STRUCTURE, NOW THE EAST BUILDING
OF CHURCH HOSPITAL, WAS ERECTED IN 1836,
TO HOUSE THE WASHINGTON MEDICAL COLLEGE.
EDGAR ALLAN POE, AUTHOR AND POET, WAS
BROUGHT HERE, ILL AND SEMI-CONSCIOUS, ON
OCTOBER 3, 1849 AND DIED FOUR DAYS LATER,
IN 1857, THE BUILDING WAS PURCHASED BY
CHURCH HOME AND INFIRMARY, WHICH WAS
RENAMED CHURCH HOME AND HOSPITAL IN 1943.

CHURCH HOME AND HOSPITAL
AND
MARYLAND HISTORICAL SOCIETY

The hospital in which Poe died was renamed Church Home and Infirmary in 1857; many Baltimoreans still call the building at 100 North Broadway "Church Home Hospital." In the 1990s, it stood vacant; by the millennium, it had been purchased by Johns Hopkins, which intended it for demolition. After much outcry, the structure was kept from the wrecking ball and repurposed to house executive apartments. A historical marker has been erected in front of the building on Broadway, and a plaque on the porch entrance states that Poe "spent his last days in this house." The property is not open to the public. (Both, author.)

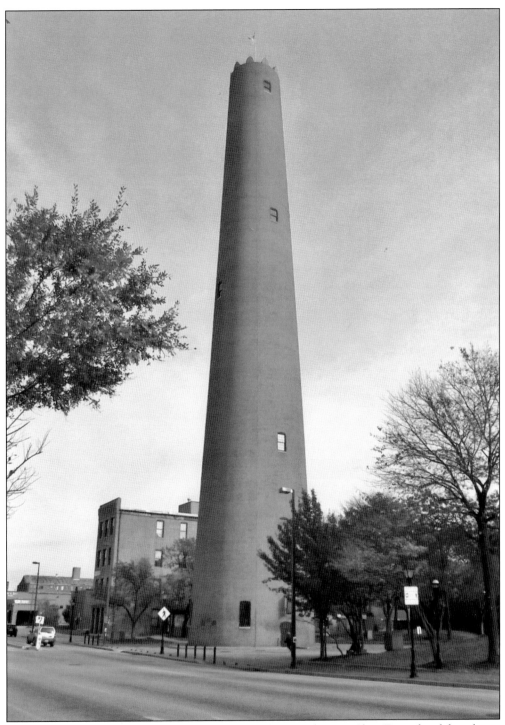

Like the Poe House and Church Home Hospital, Baltimore's historic Shot Tower faced demolition in 1921, but it was saved by private action. It is still a commanding structure almost 200 years after it was erected. Located at 801 East Fayette Street, the tower is open for tours on the weekends by appointment. (Author.)

Today, Monument Square and the 1814 Battle Monument are located at the bottom of a concrete canyon dwarfed by the more imposing structures surrounding it. A driver today will miss it altogether if trying to beat the traffic light on Fayette Street. The city courthouse shown behind the monument stands on the spot where Guy's Monument House used to be. (Library of Congress.)

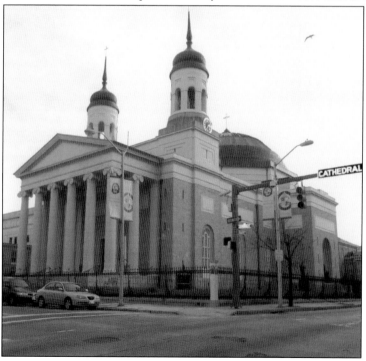

In Poe's time, the Catholic Cathedral, as it was known, was ringed with fine townhouses, including that of John Latrobe and his famous architect father, Benjamin Latrobe, which once stood where the Enoch Pratt Free Library is now. The immediate neighborhood of the Baltimore Basilica remains much the same today. (Author.)

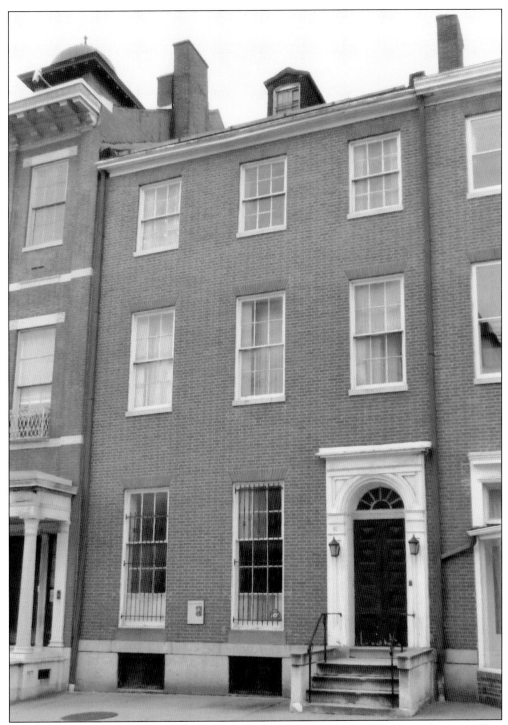

The Latrobe house can be found directly across the street from the Baltimore Basilica, at 11 East Mulberry Street. A historical plaque on the front of the house tells the story of Poe's selection as the winner of the *Saturday Visiter* (not *"Sunday Visiter"*) contest. Today, it is a private residence and not open to the public. (Author.)

When it was dedicated and opened to the public in 1934, the Edgar Allan Poe Room at the Enoch Pratt Free Library was the newest of three memorials to the poet in Baltimore. It contains an exhibit of rare portraits, first editions, and other related memorabilia. The room can be reserved for meetings and is home to the Edgar Allan Poe Society's annual lecture. (Author.)

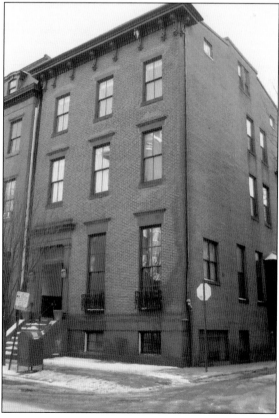

In the late 1850s, John Pendleton Kennedy moved from Calvert Street and into this house that he built at 12 West Madison Street. Among his many accomplishments, Kennedy served as secretary of the Navy and helped to establish the Peabody Institute. He died in 1870 and is buried in Baltimore's Green Mount Cemetery. Today, this house is a private residence and not open to the public. (Author.)

After more than 60 years at the Wyman Park location, Sir Moses Ezekiel's bronze statue of Poe was moved to the more appropriate Gordon Plaza on the campus of the University of Baltimore, located at the confluence of Maryland and Mount Royal Avenues. Like the burial monument at Westminster Cemetery, it is often festooned with flowers, balloons, and humans taking selfies. (Author.)

The Westminster Hall and Burial Grounds is the final resting place of many of the city's celebrated citizens, including Edgar Allan Poe. When the church congregation disbanded in 1977, control of the property was assumed by the University of Maryland's School of Law, which oversees the grounds. The historic church building has been restored and is available for weddings, lectures, and other special events. (Author.)

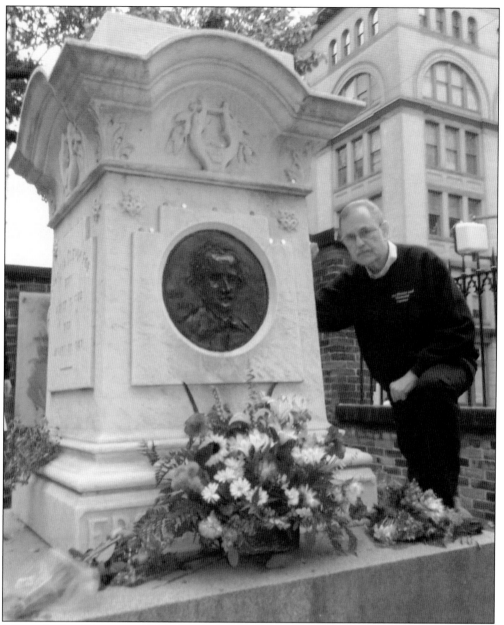

When the Poe House ceased being a city-run property in 2012, Jeff Jerome's tenure as curator came to an end after 34 years. Today, Jerome can be found at the Westminster Cemetery, but he no longer waits to help the "Poe Toaster," who he says no longer comes. Jerome is shown here at the Poe Memorial in 2014. (Author.)

Baltimore entrepreneurs have had some success in exploiting the city's relationship with Poe. The Annabel Lee Tavern at 601 South Clinton Street offers a substantial menu amid rooms with Poe-themed décor. Another is the popular nightspot The Horse You Came In On Saloon, although Poe's reputed patronage there is without foundation. (Author.)

The Baltimore "BNote" currency was launched in 2011 by the Baltimore Green Currency Association to benefit local, mom-and-pop businesses. Edgar Allan Poe was chosen for the $5 note motif, "Be More Literary." The experiment seems to be working. No matter the program's success, these are destined to become collectibles. (Author.)

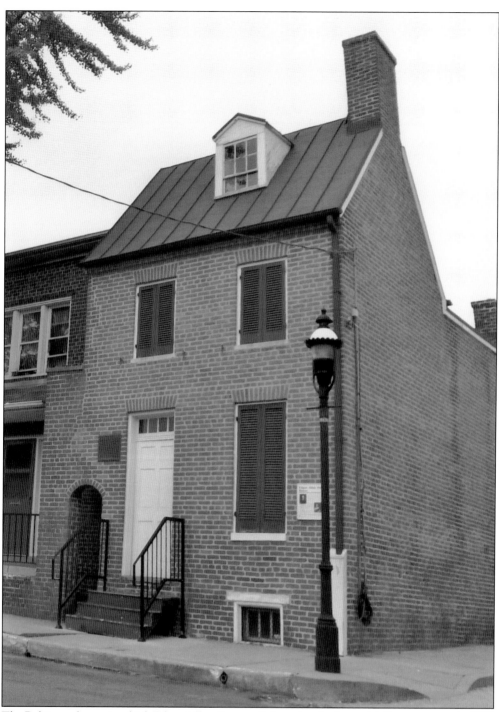

The Baltimore house in which Edgar Allan Poe was living when he began his literary career in 1833 has survived and is open to the public on weekends from May to December. Located at 203 North Amity Street, it is overseen by Poe Baltimore, a nonprofit organization created for the purpose. The little home has become a destination for Poe pilgrims from around the world. (Author.)

Those visiting the Poe House today can walk on the same floorboards and pass though doorways that Edgar Allan Poe did over 180 years ago. How many times did Maria Clemm climb and descend this narrow staircase when caring for Poe's bedridden grandmother? (Author.)

The most popular and photographed room at the Poe House is the garret bedroom, which has been furnished as though it were expecting Edgar's return. However, the bedroom assignments of the Clemm-Poe family members while living on Amity Street will probably never be known. (Poe Baltimore.)

This simple bow back chair was passed down through the family of Henry Herring, Poe's uncle. It is believed to have been loaned to the Clemm family when they lived at Amity Street and was returned when they left the house. It is currently on display at the Edgar Allan Poe House in Baltimore. (Poe Baltimore.)

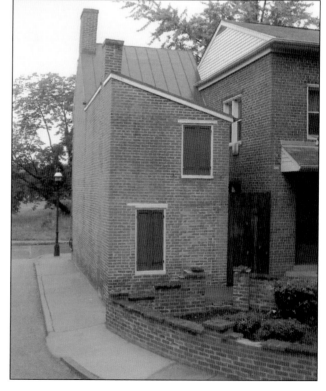

This rarely seen, rear view of the Poe House on North Amity Street shows the original 102-inch width of the kitchen and inward pitch of the rear section's roof; the five-foot extension added in the 19th century observed the existing dimensions. However, it is not clear when the rear door was removed, or if it was part of the original design. (Author.)

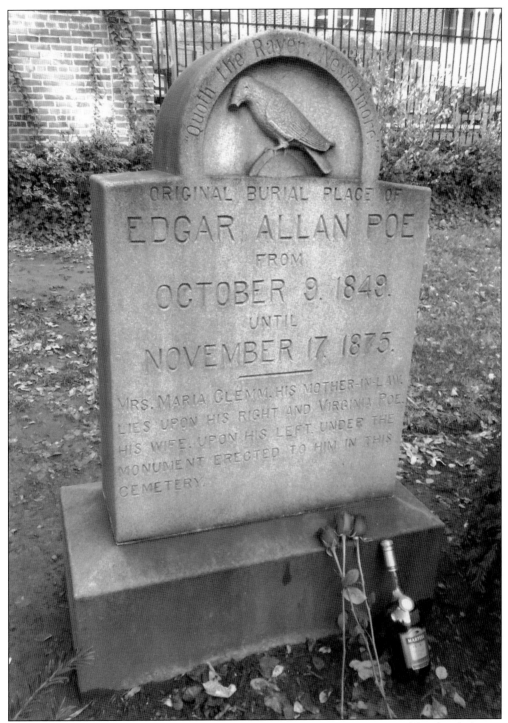

First reported in 1949, on the date of his birth, an annual tribute to Poe and his family began at the Westminster Presbyterian cemetery. The ritual included the deposit of three roses and a freshly opened bottle of cognac. The tradition apparently came to an end when the authentic "Poe Toaster" appeared in 2009 for the final time on the bicentennial of Poe's birth. (Author.)

BIBLIOGRAPHY

Beirne, Francis F. *The Amiable Baltimoreans*. Baltimore: Johns Hopkins University Press, 1951.

Bohner, Charles H. *John Pendleton Kennedy: Gentleman from Baltimore*. Baltimore: Johns Hopkins Press, 1961.

Deas, Michael J. *The Portraits and Daguerreotypes of Edgar Allan Poe*. Charlottesville: University Press of Virginia, 1989.

Evans, May Garrettson. "Poe in Amity Street." *Maryland Historical Magazine* (December 1941): 36, No. 4, 363–380.

Fisher, Dr. Benjamin, ed. *Masques, Mysteries and Mastodons: A Poe Miscellany*. Baltimore: Edgar Allan Poe Society, 2006.

Mabbott, Thomas Ollive. *The Collected Works of Edgar Allan Poe*. 3 vols. Cambridge, MA: Belknap Press of Harvard University, 1969, 1978.

Miller, John Carl. *Building Poe Biography*. Baton Rouge: Louisiana State University Press, 1977.

Olson, Sherry H. *Baltimore: The Building of an American City*. Baltimore: Johns Hopkins University Press, 1980.

Powell, Michael. *Too Much Moran: Respecting the Death of Edgar Poe*. Eugene, OR: Pacific Rim University Press, 2009.

Quinn, Arthur Hobson. *Edgar Allan Poe: A Critical Biography*. New York: Appleton-Century-Crofts, 1941.

Savoye, Jeffrey. Current editor, Edgar Allan Poe Society of Baltimore, www.eapoe.org.

Scharf, Col. J. Thomas. *Chronicles of Baltimore*. Baltimore: Turnbull Bros., 1874.

Shalhope, Robert E. *The Baltimore Bank Riot*. Chicago: University of Illinois Press, 2009.

Shivers, Frank R. Jr. *Maryland Wits & Baltimore Bards*. Baltimore: Maclay & Associates, Inc., 1985.

Thomas, Dwight and David K. Jackson. *The Poe Log: A Documentary Life of Edgar Allan Poe 1809–1849*. New York: G.K. Hall & Company, 1987.

ABOUT THE ORGANIZATION

Poe Baltimore was created to fund, maintain, and interpret the Edgar Allan Poe House and Museum, and to celebrate the legacy of one of Baltimore's most famous residents. We are dedicated to maintaining the museum as a vibrant experience for the thousands of visitors who come from around the world each year, and as part of a broader mission of city-wide events and educational opportunities.

Poe Baltimore is committed to enriching the experience of visitors to Baltimore, who come to witness the city that inspired Edgar Allan Poe and his intellectual and literary heirs. We are committed to protecting, preserving, and celebrating the rich history of the city, the house, and the legacy of one of our most beloved denizens.

DISCOVER THOUSANDS OF LOCAL HISTORY BOOKS FEATURING MILLIONS OF VINTAGE IMAGES

Arcadia Publishing, the leading local history publisher in the United States, is committed to making history accessible and meaningful through publishing books that celebrate and preserve the heritage of America's people and places.

Find more books like this at
www.arcadiapublishing.com

Search for your hometown history, your old stomping grounds, and even your favorite sports team.